THE CHAN(

C000214917

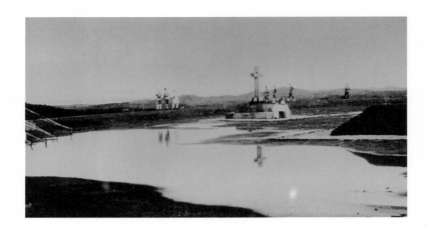

"In war or in life everything that happens has a reason..."
Frank Rups, Dutch Armed Forces

"After so many years of hating, my visits to the cemeteries at Kanchanaburi, Chunkai and Kranji culminating in the sight of these wonderful Murals brought upon me a sense of peace I have not had for a long time."
Ron Upton, Royal Artillery

"Whether one is a believer or not, the murals serve as a very poignant memorial to all those who served and suffered in Singapore."
W. Brand, Royal Army Medical Corps

THE CHANGI MURALS
The Story of Stanley Warren's War

Peter W. Stubbs

◦LANDM△RK◦BOOKS◦

Dedication

—

*To all the servicemen, servicewomen and civilians
who suffered cruelly, and to those who died at the hands of the
Japanese during World War II.*

Illustrations

Frontispiece: The Bukit Batok Memorial built by British POWs to fallen comrades, 1942.

Front cover, top: Stanley Warren's small painting of 'St Luke in Prison' – the only existing replica of the original mural.

Front cover, bottom: Stanley Warren, restoring the Cruxifixion mural on his first visit, speaking to an officer, 4 January 1964.

Back cover: Stanley Warren's forward observation post sketch of the Causeway dated January 31, 1942.

Contents

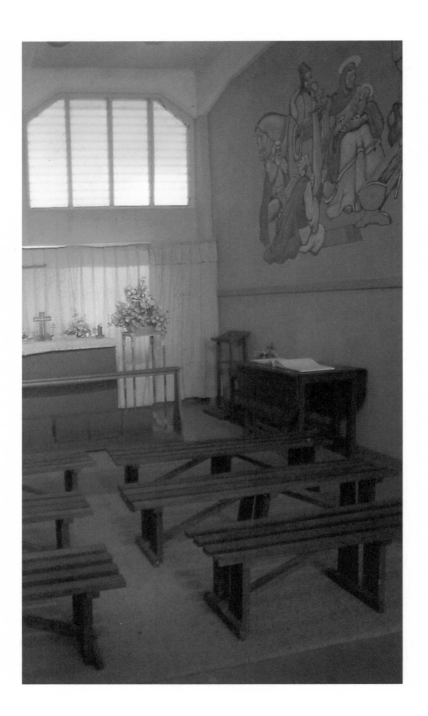

Prologue

In 1934, a talented but bored teenager was poring over dry books on art history in the Hornsea School of Art. At the same time, across the world on the island of Singapore, a military camp was being built on the Changi peninsula.

Eight years later, the young artist would be brought to Changi – as a prisoner of war – and there he would create a series of murals which has since become a lasting reminder to the futility of war and the hope of universal brotherhood.

* * *

STANLEY WARREN WAS BORN IN ENGLAND, 1917. After graduating from art school, he was employed as a commercial designer with the Grenada organization. Grenada ran a chain of cinemas, and Stanley's job was to produce large posters advertising the film shows. He was 17 then, and the year was 1939, when the dark shadows of war were falling over Europe. News of Nazi Germany's advance across Europe concerned Stanley greatly. "I really wanted to do something to stop it," he said.

In January 1940, when World War II was four months old, Stanley put his words into action. He went to Ipswich in the eastern county

Present-day view of St Luke's Chapel with Nativity mural (right).

of Suffolk and enlisted in the army. Like all who 'joined up', he was asked his civilian calling. When he replied that he was an artist, he was posted to the Royal Regiment of Artillery as an Observation Post (OP) Assistant, whose responsibilities included having to make very quick drawings of panoramas used to plot targets for the guns. Following six weeks of basic training, Stanley was posted to 344 Batallion, 135 Regiment. There he honed his skills in the various exercises conducted to prepare an army for active service.

When it was time for Stanley to be sent overseas, he and his comrades set out to cross the Atlantic on a small Polish vessel, the *Jansoviask*, which was part of a large convoy carrying the 18th Division. War in Malaya had not broken out at this time, and the division was earmarked for service in the Middle East theatre. America, not yet drawn into the war, was nonetheless overtly assisting the British War effort by assigning US navy warships on escort duties.

Arriving in Halifax, Nova Scotia, Stanley was transferred to an American luxury liner, the *Mount Vernon*, which was being used as a troopship. His journey now took him south past Port of Spain where he was a member of a detail which took some sick men ashore. From there the convoy travelled to the South Atlantic and turned towards Cape Town, South Africa. Such a convoluted route was necessary to avoid the German U-boats which ranged across the ocean. From Cape Town, the troopships went up the east coast of Africa to the Kenyan Port of Mombassa.

It was here that the men were told that the Japanese had invaded Malaya and Thailand, and Pearl Harbour had been bombed, bringing America into the war. A new war arena had been created, and the *Mount Vernon*, along with other ships, was diverted to Singapore to fight a new enemy.

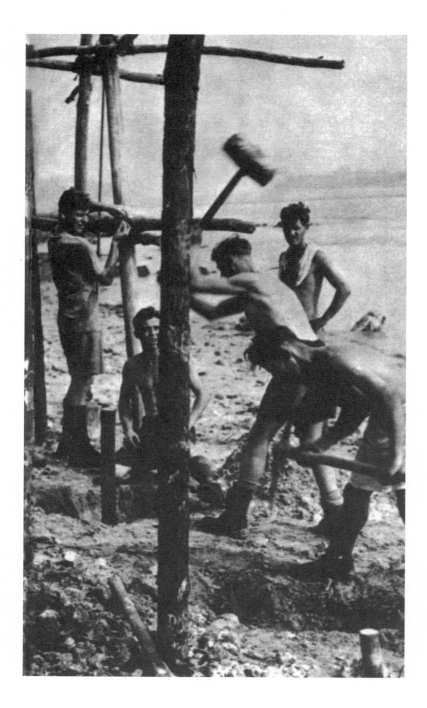

1 | Changi and the Paper Fortress

PRIOR TO 1921, CHANGI was just a quiet little kampong and rubber-growing area on the north-eastern tip of Singapore island. Events several thousand kilometres away were about to change that once and for all.

Early in 1921, the British Government of the day instructed the Committee of Imperial Defence to determine where in the Far East to locate a new naval base. The base had to be close enough to an area of possible operations (Japan was even then considered to be a potential threat). It also had to be near refuelling points and have an adequate, trained labour force. The defence of the base was also a major consideration.

Due to limitations imposed by treaty obligations with the United States of America and Japan, the base could not be established east of the 110° line of latitude. Consequently, apart from constructing the base on the coasts of Australia, the base would have to be either in Malaya or Singapore. Admiral of the Fleet Lord Jellicoe had recommended Singapore as a suitable site for a naval base whilst he was on a Far East tour shortly after World War I. Importantly, Singapore was closest to the prospective theatre of operations.

It was thought that because Japanese bases were a considerable distance away and Malaya was jungle covered, a land attack could be

British WWII soldiers building a coastal defence, Singapore.

discounted. All that would be necessary was the installation of fixed coastal defences of sufficient strength to deter even the most aggressive enemy. A fleet based at or sent to Singapore would then be able to defend Malaya, and to safeguard Britain's communications and commercial interests in the area: Malaya with its tin and rubber, and the Dutch East Indies with its oil. The Committee of Imperial Defence therefore concluded that Singapore should be chosen for the site of the new naval base, and recommended it to the government. This recommendation was accepted by the British Cabinet in June 1921.

Early in 1923 the site for the new naval base was chosen by a subcommittee of the Committee of Imperial Defence. After examining several sites, including one in the Straits of Johore close to Changi, the Committee decided that the naval base would be constructed in the Straits of Johore, just east of the Causeway connecting Singapore to Malaya. Outline plans of the new defences for the naval base were drawn up at General Headquarters, Singapore, in 1926. These included a major army cantonment to be located at Changi.

The name Changi is taken from the colloquial name for a tree of the *Balanocarpus* species. These tall and valuable timber trees once were common in Singapore. Changi in 1927 was partly forest with many trees exceeding 30 metres in height. One of these was well over 45 metres and was marked as 'Changi Tree' on Admiralty maps, as a reference point for shipping. The undergrowth was very thick, and low-lying areas were covered by mangrove swamp.

The gun defences to be constructed at Changi were to comprise a three-gun 15-inch battery at Bee Hoe, a two-gun 6-inch battery on a hill, later renamed Battery Hill, near the small village, and another two-gun 6-inch battery by the sea at Telok Paku. These would become the Johore Battery, Changi Battery and Beting Kusah Battery respectively. Significant clearing work was carried out to make way for fields of fire and accommodation. By the end of 1927, most of

View of the Changi Tree with Roberts Barracks, 1938.

the northern swamp, including that around Selarang River, had been reclaimed. Roads and a small standard gauge railway of 1 mile (2.4 km) to transport heavy ammunition and stores for the guns were being built.

To house the artillerymen and their support arms, two barracks, Roberts and Kitchener, were to be constructed at Changi. The Royal Engineers would eventually reside in Kitchener Barracks, and the 9th Coastal Artillery Regiment of the Royal Artillery in Roberts Barracks.

In 1930, after three years of hard work, the building of Changi was abruptly halted. The reason was one of those political decisions which so often cripple British defence capability. The new government in Britain headed by Ramsay MacDonald found itself short of funds in the midst of the Great Depression. Severe defence expenditure cuts were made, and one of the casualties was Singapore. At Changi, all work was stopped.

In 1931, Japanese expansionism in Manchuria forced a rethink, and a new British National Government, still headed by MacDonald, ordered that work on Singapore's defences be resumed. In 1932 came the decision to complete Changi. Despite this, it took another year

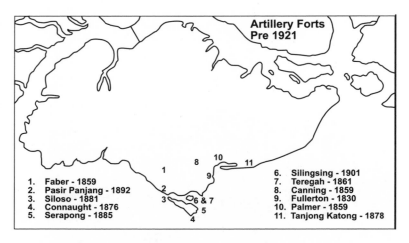

before the building work recommenced. By 1936, Changi was finally ready for its first armament.

That same year, Lt. Col. Arthur E. Percival arrived in Singapore to take up the post of GSO in HQ Malaya Command. The GOC Malaya, General W.G.S. Dobbie, gave Percival the task of carrying out an appreciation of Malayan defences against attack. Percival went to work on his task, travelling extensively throughout Malaya. His appreciation concluded that an enemy, probably Japan, would land in the north of Malaya and in the south of Thailand, and then advance down the western coastal strip of Malaya towards Singapore. The appreciation recommended that Malaya and Singapore's defences be bolstered by a massive increase in defence capability. Percival recommended additional infantry battalions, the introduction of tanks into the theatre, and over 300 combat aircraft. He, like others before him, realised that improved roads and a railway system would be of great help to any strong attacking force which overwhelmed a weak defending force. He also knew that the jungle was not impenetrable, and that there were many miles of beach which were ideal for landing troops on. His appreciation was sent to the War Office in London and filed away without any action being taken.

The defences of Malaya and Singapore were not reviewed again

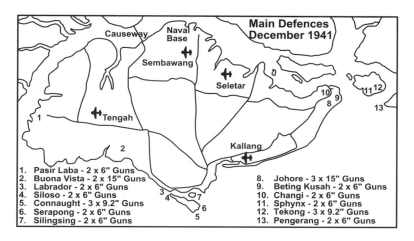

Main Defences December 1941

1. Pasir Laba - 2 x 6" Guns
2. Buona Vista - 2 x 15" Guns
3. Labrador - 2 x 6" Guns
4. Siloso - 2 x 6" Guns
5. Connaught - 3 x 9.2" Guns
6. Serapong - 2 x 6" Guns
7. Silingsing - 2 x 6" Guns
8. Johore - 3 x 15" Guns
9. Beting Kusah - 2 x 6" Guns
10. Changi - 2 x 6" Guns
11. Sphynx - 2 x 6" Guns
12. Tekong - 3 x 9.2" Guns
13. Pengerang - 2 x 6" Guns

following Percival's appreciation. Improper and inadequate inland defences were therefore set in place, with no real thought being given to countering an attack from the north, and without strong Royal Air Force (RAF) reinforcements. Certainly, the coastal defences were strong, and provided a deterrent to seaborne assault, but the north was open and inviting.

By 1941 the work at Changi was complete. Roberts and Kitchener Barracks and India Lines had been built, as well as Selarang Barracks which was to house the 2nd Battalion Gordon Highlanders. Changi was finally ready for action – something that few believed would happen. The myth of 'Fortress Singapore' had been born.

The war in Europe which started in September 1939 had little impact on servicemen and civilians alike in Singapore. With Singapore fortified and standing ready, there were no thoughts of war in the East – Singapore defences were believed to be just too strong. The Japanese, however, had been preparing for war for many years. Their plans for the taking of Singapore did not include a seaborne assault. The Japanese had a first class, highly motivated intelligence service. With its kampong barbers and photographers and other agents, they knew exactly what the defences of Malaya and Singapore comprised. The Japanese intelligence services had over a period built

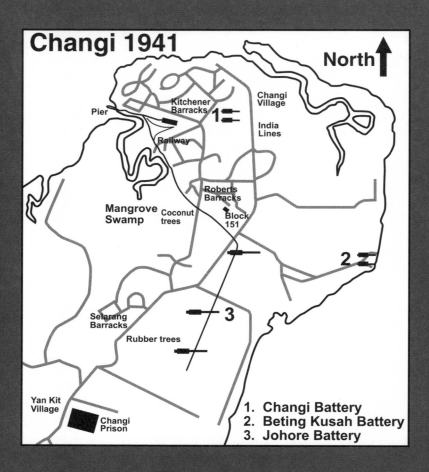

Changi 1941

North ↑

Pier

Kitchener Barracks

Changi Village

India Lines

Railway

Mangrove Swamp

Coconut trees

Roberts Barracks

Block 151

Selarang Barracks

Rubber trees

Yan Kit Village

Changi Prison

1. Changi Battery
2. Beting Kusah Battery
3. Johore Battery

up a comprehensive knowledge of British preparedness and abilities. They knew that British forces were desperately short of war material and men trained in jungle warfare, and that there were precious few front-line aircraft and no tanks. Finally, there was a modern, well-equipped naval base devoid of large warships. (The war in Europe meant that there was never any real possibility of a powerful British naval force being sent to defend Singapore.) They also knew that the chances

Arthur E. Percival's return to Singapore as GOC in May 1941.

of an effective reinforcement from Britain and its allies were very slim indeed. The odds were heavily weighted on the Japanese side.

In April 1941 Percival was promoted to Acting Lieutenant General and returned to Singapore as GOC Malaya Command. He arrived in Singapore in May. Just over six months later, his appreciation of an attack on Malaya became reality.

The British prime minister, Winston Churchill, knew the parlous state of the defences, and the last thing he wanted was another war front. To try to deter the Japanese from going to war, he decided to send a small force of warships, to be called 'Force Z', to Singapore. They were HMS *Indomitable* (armoured fleet aircraft carrier), HMS *Prince of Wales* (battleship) and HMS *Repulse* (battlecruiser). The *Indomitable* and the *Prince of Wales* were new, but the *Repulse* dated from World War I. A handful of destroyers were to go with them. The *Indomitable* ran aground at Kingston, Jamaica on her way to Singapore and was unable to continue. Despite the loss of the aircraft carrier from the force, Churchill unwisely insisted on the *Prince of Wales* and the *Repulse* continuing their journey. The warships and their train of destroyers arrived in Singapore to great public acclaim on 2 December 1941.

Japanese troops advancing in Gemas during the invasion of the Malayan Peninsula, Jan. 1942. [AWM 127894]

It could be argued that the coastal batteries built in Singapore did their work effectively without firing a shot. The Japanese knew all about them and planned accordingly. On 7 December 1941, a little less than an hour before their attack on Pearl Harbour, the Japanese landed in the north of Malaya at Kota Bahru. Other landings took place at Singora and Patani in southern Thailand. The prophets of earlier years had been vindicated. On the following day, the *Prince of Wales* and the *Repulse* left the naval base and slipped under the cover of the guns of Changi down the Johore Straits. They were both caught without air cover and sunk off Kuantan on 10th December by Japanese aircraft operating from Indochina. The great guns of Changi now covered the sea approaches to an empty naval base.

The brilliantly conceived and executed Japanese drive down Malaya has been much written about, and will not be covered here. Suffice it to say that if recommendations for infantry, tanks and aircraft made by Percival and others had been acted on, things may just have been different.

The Changi Garrison sat and waited, there was not much else for them to do. There were a few bombing raids, which caused some damage in Changi Village, but until February 1942, the war did not really affect Changi. Then the Japanese, just over the Straits of Johore, let loose their artillery and air power on Changi. There was heavy bombing and shelling, and buildings were damaged and destroyed, with the artillery magazine being one of the buildings damaged.

On the evening of 7 February 1942, the Japanese 5th Imperial Guards made a feint attack on Pulau Ubin. The Changi guns and those from nearby Pulau Tekong fired on them, but without great effect because of their shortage of high explosive (HE) ammunition. The main Japanese assault on Singapore began on 8 February with a landing at Sarimbun on the western side of the island.

There has been since the war an enduring myth that the guns of Singapore faced the wrong way. Figuratively speaking, this is true in

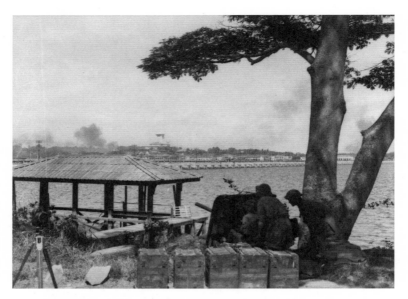

Australian Imperial Force gunners overlooking the Causeway, early 1942. [AWM 012449]

that defense was completely oriented for an sea-bound attack from the south. Technically, however, all the coastal guns could engage targets in any direction as they were capable of all-round traverse, with the exception of the Buona Vista 15-inch battery and one 15-inch gun of the Johore Battery. As a result of the defense strategy, the location of the guns and type of ammunition were only suited to counter a southern attack from the sea. The coastal artillery meant they were well supplied with armour-piercing ammunition for anti-shipping use, but not with HE shells for anti-personnel and counter-battery operations, which became necessary when the Japanese entered via Malaysia.

By 12 February, the situation in Singapore was desperate and Percival ordered the Changi Garrison to withdraw to Singapore Town. Before they withdrew, the Royal Engineers blew up the guns which had been Changi's raison d'etre. Fortress Changi's role in the defence of Singapore was over.

At 1715 hours on 15 February, Percival made his humiliating walk along the short road leading to the Ford Factory at Bukit Timah. There, the victorious General Tomoyuki Yamashita was waiting to accept the surrender of Singapore. The surrender document was signed at 1810 hours. The paper fortress had crumpled untested by an assault from the sea, and over 80,000 troops went into captivity. Singapore had been taken in 70 days – a little over the time the Japanese had planned on.

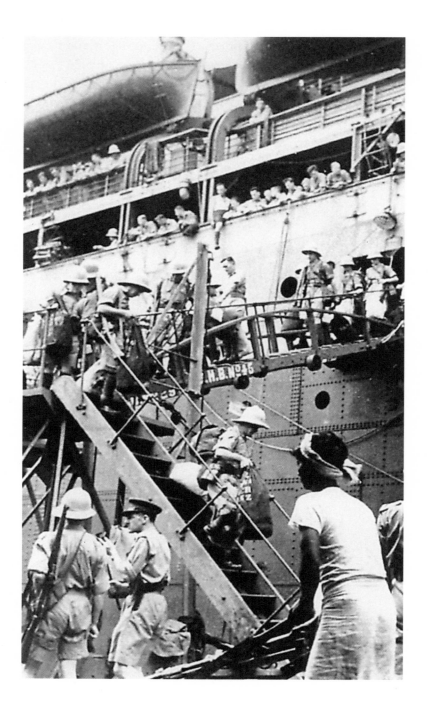

2 | Stanley Warren's War

STANLEY ARRIVED IN SINGAPORE IN JANUARY 1942. They had a rough ride through the Sunda Straits and torrential rain greeted their landfall. Throughout the journey, the soldiers had been kept informed of the desperate situation in Malaya, but once in Singapore, Stanley found that censorship hid the reality from the troops, the purpose – to maintain morale. The next day, Stanley saw first-hand the lack of Singapore's defensive capability. A Japanese bombing raid took place, and the few Brewster Buffaloes which took to the air to intercept the attackers were "virtually sitting targets" for the Japanese escort fighters.

Once Stanley's battalion had collected their guns from the docks, they were immediately sent to Johore to try to bolster defences. As they were going towards Batu Pahat, possibly Ayer Hitam (Stanley, the OP Assistant, could not tell as he did not even have a map in hand), the lead troops were ambushed. "It was the usual story, trees fell across the road, machine guns and mortar bombs secreted on each side.... What they did do here was they managed to get some of the vehicles off the road, round in a circle. And I was told ... that it was a little bit like cowboys and Red Indians." A number of casualties were incurred and two guns and several men were captured.

British troops disembarking in Singapore before the Japanese invasion, 1941.

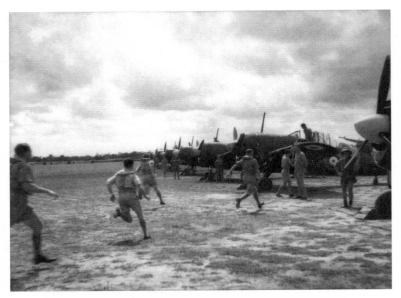

At Sembawang airfield, RAAF pilots run to their Brewster Buffalo aircraft in response to a scramble order. c. 1941–42. [AWM SUK14775]

Stanley thought that the 18th Division was unprepared for war, and in this he was correct. The men had been at sea for many weeks, then rushed straight to the front line. They were unfit from the long sea voyage, had no period of acclimatisation to the heat and humidity, and were unable to carry out any battle training exercises to prepare them for jungle warfare.

Once at their destination, Stanley was sent to Pulau Pisang along the Straits of Malacca with an officer and some Gurkha troops to establish an OP on the island. Their job was to report troop movements to the OP on the mainland coast. However, the radio equipment they were issued was found to be next to useless because it was jammed by electrical disturbances. So, during daylight, they resorted to a heliograph – a device which sends messages by morse code by reflecting the sun's rays to a distant point, or by using a lamp with batteries at night. By this time, Stanley had discovered the downside of being an OP Assistant. "You're often out in front of the infantry,

you're in the most endangered position. Obviously, we've got to be in front of all the forces or at least where you could observe the artillery, the foregrounds and so on."

When Batu Pahat was evacuated, Stanley was taken to Sime Road in Singapore where he made a drawing of the retreating troops. With just time enough for a meal, he found himself in a truck again, heading for an OP located in an unfinished building to the right of the Causeway linking Singapore and Malaya. There, he quickly sketched a panorama of the coast, registering the important targets. These included the creeks across the Straits of Johore from where Japanese troops could launch their boats in an attack, as well as the gap blown up in the Causeway by the retreating British forces. Named 'Queenie 1' as a target point, the gap had actually cut a large number of Allied men off on the Malayan side. The fortunate ones found their way to Singapore by boat. The many who did not were taken prisoner by the Japanese.

"Well, it wasn't very long before the Japanese arrived on the scene…. The Japanese made several attempts to throw a rope bridge across the gap. Accurate artillery fire was brought down on them. This was followed by using the guns to demolish some buildings on the Malayan shore to prevent them from providing cover to the Japanese." Now, Stanley and his comrades saw some boats in Skudai Creek ('Queenie 2') and fired on them. They fired on every Japanese target they could reach. Some targets were beyond the effective range of their 25-pounder field guns (11,000 yards), and that galled the gunners. "The Japanese knew exactly the range and knew everything about the guns, that was quite clear. They used the water tower in Johore Bahru as the major look-out post. And all [their] senior officers – we could see [them] with our binoculars and telescopes – up there with all their equipment, watching and directing the action. It really was so infuriating that we could not knock them out." What frustrated the gunners even more was that there was no air support to speak of.

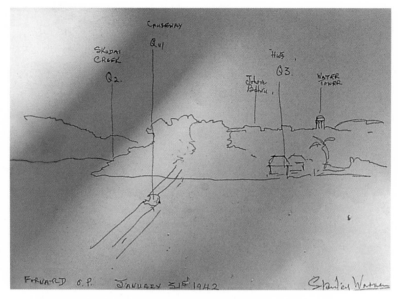

Stanley Warren's forward observation post sketch of the Causeway dated January 31, 1942.

Following a sustained artillery barrage, the Japanese landed at Sarimbun at 2230 hours on 8 February. The defending troops were quickly pushed back and a firm foothold on the island was gained by the invaders who rapidly consolidated their position before pushing forward. Stanley was now moved to Kranji Hill, where shortly he found a gunner's dream target. Due to heavy Japanese bombardment of oil tanks at Seletar, a great black pall of smoke had gone up. "And then the wind ... moved over to Johore and this great pall of smoke went over like a black ceiling. To our amazement, we could see the Japanese artillery ranged out across the golf course, all the missile flashes ... going ... in order to deliver them into our hands." The target coordinations were rapidly transmitted to the Battery Command Post and to use an artillery term, the Japanese guns were 'stonked'. The whole line of Japanese guns disappeared in the shell-bursts. "Then we had a little bit of bad luck. We were out in the open ... there was no way we could dig any pit or trench because the

rocks were just below the surface. Now came the real problem. The Japanese spotter pilot looked over and saw us. They were obviously searching for the OP. He called up three bombers and they all unloaded on us.... It was deafening – we covered our ears, of course, and buried ourselves in the dirt. I was quite surprised. We got up, shook ourselves down. There was no damage done at all." Now that the OP was compromised it had to be abandoned. Stanley went down to the bottom of their position and almost ran straight into a party of Japanese soldiers. He froze in a stand of rubber trees and was fortunate to be able to return to the OP to alert his comrades.

Stanley's unit began a westerly retreat towards Tengah airfield. However, safety was still not reached by the time they reached MacRitchie Reservoir. Japanese bombers were overhead seeking targets and one spotted them. The plane came in over and let loose sticks of bombs. One exploded in the reservoir and covered the escapees in black mud. Another bomb exploded in the trees, showering them with branches. The party finally made its way safely to Corps HQ. There, Stanley instructed a driver to move trucks from a position he considered exposed. No sooner had the armoured OP cars been moved when a barrage of mortar bombs landed where they were situated.

Further withdrawals took Stanley through a village in the northwest. Almost invariably, barbed wire was put around the kampong. There were desultory bursts of machine gun fire, mortar bombs and shells whizzing over. Yet, the men folk of the village went out and tended and gathered their crops while the children played outside. Of course, when missiles came close, they immediately crouched under the huts. "A party of Japanese came in to the banana plantation just beyond the perimeter, and my officer-commanding ... began arranging four guns and we absolutely covered this plantation. But gun number 4 was slightly off switch ... so we called the Indian troops and got a mortar to come up ... so the whole of the plantation received thorough saturation. We didn't see the Japanese after that ... and they

didn't attempt any further assault on that village. I was very, very grateful because of the children … at least we'd stopped that."

In another village, the retreating troops were generously given food and water. Such a simple act of kindness would stay with Stanley all his life.

In the end, after further orders to fall back, there was no more fighting and no place to position OPs. During the retreat, Stanley was enraged to find the total lack of any effective air-raid precautions. The civilians had to run to the nearest monsoon drain for cover when shallow trenches prepared as bomb shelters would have saved many casualties. He recalled the image of a junior officer holding the body of a Tamil girl across his knees. "He was weeping over the body. The girl had been killed by a blast. And there was no sign of injury apart from the stream of fluids from one of the nostrils. She was such a pretty child. We had to take the body from him and point out that there was nothing now that could be done." Stanley himself saved a Chinese boy. "He had been peppered with stones that had been thrown out by a bomb. Now, the injuries were not serious. This poor little Chinese boy, hair cut in a circular fringe. And he didn't cry … he was just shivering. I gently carried him down to the road and got an ambulance to take him. I just hoped that someone would be able to take the stones out and cauterize the wounds. Just looked at me, I can still see his face."

The retreat continued into the city. There was total confusion. The OP personnel had swapped their armoured car for an 8-cwt canvas-covered vehicle. Stanley had fallen asleep and woke up to find himself alone in the stationary vehicle. "I saw all the people crouching in the drains; the driver and signalman … may have shouted to me. I went to the monsoon drain and found them. You can just imagine I swore at them."

Nearby a small crowd of soldiers were in the middle of the road.

PAGES 29–31 Stanley Warren made these three drawings with red wax pencil used to mark maps, on thin file card that was used for drawing artillery panoramas.

Stanley Warren's sketch of the disembarkation of the 53rd Infantry Brigade, 1942.

The 22nd regiment of Gurkha members resting, 1942.

Transit camp, Sime Road. Exhausted troops arrive from Southern Coast Johore, 1942.

Life goes on after an air raid, c. 1942.

A young anti-aircraft officer was blowing up his guns in preparation for capitulation. One of them had not gone off, and when he went towards it, the gun exploded and shattered his left leg. "I saw the man was bleeding to death. The trouble was the Japanese planes were over all the time and the fighters were strafing. So I lay on the road ... beside him and pressed my thumbs on the artery to stop him bleeding any further. I was hoping that if the fighters came ... and if they see that great patch of blood and see two figures there, they won't bother [because] they'll think I was dead anyway." The ambulance took a long time to come and Stanley's thumbs became numb and painful from trying to stanch the wound. Despite his efforts, the officer died through loss of blood. "I can almost see him now – the young man's face, his grey eyes, the perspiration on his face."

With his hands covered with drying blood and with no water to wash it off, Stanley took out the table knife from his kit and scraped off the blood.[1]

By the time of Lieutenant General Percival's surrender of Singapore,

Stanley was well into the city itself. There they destroyed their guns and personal weapons and waited for the victors to arrive. During the night, Stanley and his comrades heard evidence of the atrocities that the Japanese had begun against the civilian population as bursts of machine-gun fire and screams resounded through the city. On the following day, they saw concrete evidence, heads stuck in spikes with threatening notices underneath them. Stanley's active war was over. Now followed captivity.

Note

1. In his oral history interview, Stanley Warren recounted an experience he had two or three years after the war. He was back in England teaching when a boy let a door swing back to another boy's hand and severed an artery. Stanley held the injured hand against the wall to stop the bleeding. After the ambulance had taken the boy away, he went back to his desk and fainted – "slipped under the table." In his own words, "I was back on that road again.... You don't really lose these things."

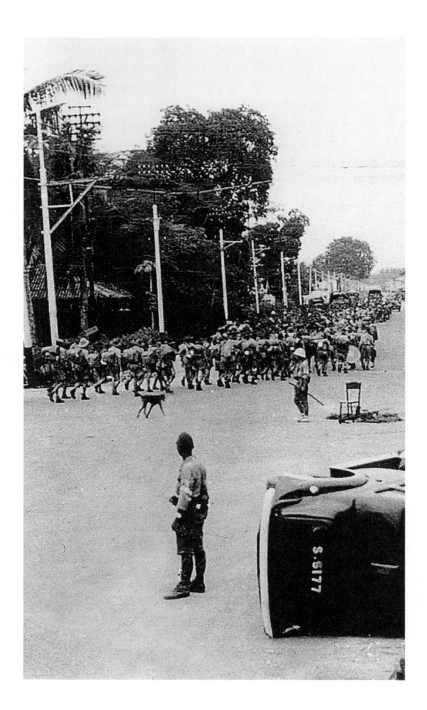

3 | Prison Camp

THE JAPANESE WERE ASTOUNDED at the sheer number of prisoners they suddenly found themselves with. Clearly they had to do something with them, and quickly. They rapidly made a decision to segregate prisoners on racial lines. Certainly by segregating the Indian troops, the Japanese would be better placed to recruit them for the Indian National Army – an army they hoped would fight with them against the British.

Several areas of the island were chosen for POW camps. The Changi Cantonment was one of these as it would be large enough to hold a great many prisoners. The 15,000 Australians went into Selarang Barracks which had been built to hold but a battalion of infantry. The 35,000 British continued on their weary way to Roberts and Kitchener Barracks and India Lines. There, they were segregated, each with his own division and were to be later joined by Dutch servicemen captured in the Dutch East Indies (Indonesia). Indian and Gurkha troops were to be dispersed elsewhere on the island. British and Allied civilians were to be interned in Changi Prison.

The order for all POWs to move to Changi was given on 16 February, and from then until 18 February, prisoners walked the 15 miles eastward from Singapore Town to Changi; only the wounded would have transport. According to Stanley, "There was this great stream of soldiers, [with] more ... joining the column all the time."

British POWs marching on the road to Changi, 1942.

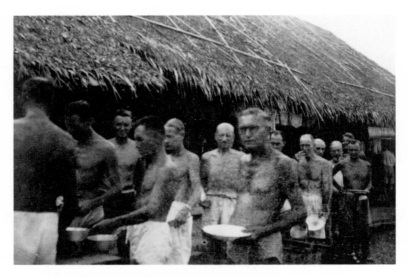

Queueing for food at Sime Road Camp c. 1944–45.

Over 50,000 prisoners would make the journey. They carried whatever possessions they could. Many had come direct from the areas where they had been fighting, and therefore had little or nothing in the way of clean clothing or other goods. On each side of the road, particularly at the kampongs on the way, there would be civilians watching them go by. Many of them risked more than just the anger of the Japanese by passing money, food and other items to the prisoners. The Chinese, in particular, knew what would befall them if they were caught, having heard what the Japanese had done to their countrymen back in China.

Stanley went into Roberts Barracks where his colonel gathered his men and addressed them. He spoke of their courage, and the way they had carried out their duties well. The unit had taken many casualties, particularly when a gun position had received a direct hit, and an entire crew was killed. The colonel and Stanley had become close comrades during the battle for Singapore. Stanley recalled a conversation he had with the officer soon after imprisonment. "The colonel said to me, 'How long do you think we are going to be here,

bombardier?' I said, 'I'm afraid I have to tell you that we are likely to be here a very long time.' He said, 'What do you mean?' I said, 'Possibly four years.' He said, 'What chance do you think we can survive?'" Stanley told the colonel about the films he had seen in London of Japanese brutality in Shanghai, and added, "I don't think we've all got that chance."

Civilian internees, numbering some 3,500, walked to Changi Prison over the next week. The men were the first to make the journey. When the women and children arrived, they were kept segregated from the men, and only allowed to meet rarely, on occasions such as Christmas. The prison, built in 1936 to hold some 600 people, was to be their home until 1944 when those who had survived the first two years of an exceptionally harsh internment were moved to Sime Road Camp. There, conditions were also bad, and many more did not live to see liberation.

Despite battle damage, the Changi Cantonment had, at first, a lot to offer the POWs. The Japanese initially left them to their own devices and there were still British Army rations to be had. Apart from relaxing and dreaming of home, there was little to do. The senior officers, however, soon re-introduced military discipline which was bitterly resented by the imprisoned troops. The name 'Malaya Command' continued to be used by these officers adding fuel to the

Sime Road Camp, c. 1944–45.

men's resentment of what they saw as a failed command.

Lieutenant General Percival was held in Roberts Barracks until, with all senior officers above the rank of Lieutenant Colonel, he was sent to Formosa (Taiwan) by the Japanese. Before leaving, he promoted Lieutenant Colonel Holmes of the Manchester Regiment to full colonel and nominated him as camp commander. The Japanese would not recognise the promotion, but did accept Colonel Holmes as the camp commander.

The Japanese made their attitude to the POWs very clear. Anyone attempting to escape would be executed. In this they kept their word. Stanley tells of one incident. "Six Eurasian who were members of the medical corps escaped. They were brought back. And then the Japanese ordered all the officers and warrant officers to attend the executions. And these large number of men were arranged round the square and then Indian soldiers were ordered to fire at the extremities of the men. And so took place the most awful, macabre event. The slow motion execution of the six men who tried to escape." There were, however, several escapes from Changi. In one such attempt, a Major Campbell, Lieutenant Martin, and a Sapper Morris from 30 Fortress Company RE, took a boat, the *Goldeneye,* from the Changi Garrison Yacht Club. They set sail on 19 February and got as far as the Sunda Straits before being picked up on

**ABOVE & TOP LEFT
Staircase murals painted by Stanley Warren in 1981 based on his 1942 mural designs for the staircases at Roberts Barracks.**

5 March, desperately short of rations, by the Japanese cruiser *Asigara*.

All prisoners had to bow to Japanese soldiers of any rank. All Japanese soldiers had the authority to mete out physical punishment for any misdemeanour, actual or perceived. This they did with relish. Even Percival was beaten up when he attempted to intercede on behalf of his men. He was assaulted several times, and was locked up for three days without food. This was for refusing to order his men to repair anti-aircraft guns.

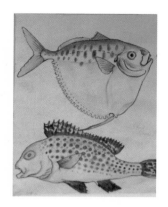

Stanley Warren's painting of marine fishes included in the fish ration.

Stanley found the first taste of captivity quite traumatic. To keep himself occupied and to try to forget the horrors he had seen during the previous five weeks, he drew tropical fish that he had kept in England and designed murals for the staircases at Roberts Barracks. The staircase panels were scenes of Singapore rural life. Never having been out of England, the luxuriant tropical growth fascinated him. So the drawings are filled with idealized images of happy villagers under palm fronds and banana trees, and include lovely details such as playful monkeys and lizards lazing in the sun.

* * *

The Japanese realised that they had a vast pool of labour to repair the damage they had inflicted upon Singapore. Work parties consisting of the prisoners were soon seen around the island repairing damage and getting essential services back into working order.

The Japanese also sent prisoners to build a road and stairs leading to a memorial to the Japanese dead on Bukit Batok. (The stairs and road, now called Lorong Sesuai, are still there to be seen.) Stanley

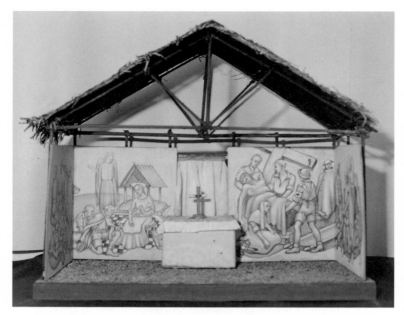

Miniature model of St David's Church with murals. Though first drawn at a Bukit Batok church, they later reappeared at St David's c. 1945.

was one of those sent to work on the hill. The signs of the intense battle for Bukit Batok were still strewn around. Decomposing bodies of the defending troops were lying where they had fallen, and the prisoners had to bury them. Stanley himself was in charge of one burial party. He found it to be a horrific task. "You'd get a young man and all that was left was just the blackened skeleton with a piece of equipment, steel helmet still there."

The food given to the prisoners was of poor quality and inadequate for a man working as slave labour. As a result of this, and the harsh treatment meted out by Japanese guards, the men's health began to suffer.

The prisoners found a measure of solace in a small, open, attaproofed chapel at Bukit Batok. The chaplain of the regiment, learning of Stanley's artistic talent, asked him to decorate the asbestos walls at the altar area. With charcoal salvaged from around the camp, Stanley

A painting of St. David's Church at Sime Road Camp by William Haxworth. The murals are faintly discernable in the background, 1945.

drew two murals: 'Nativity', which featured a Malay Madonna, and 'Descent from the Cross' in which he included soldiers in uniform, using his comrades as models. (See *Appendix 1*)

By then, Stanley was becoming very ill and was in constant pain, so much so that he could not lie down on the wooden boards of his bunk. His comrades made him a wire bed of chicken mesh. He was dying of severe renal disorder complicated by amoebic dysentery.

* * *

Shortly after the British surrender, in March, a small infectious disease hospital was set up in Changi Post Office. Battle wounds and

PAGES 44-45 **St. David's Church Murals by Stanley Warren using charcoal on asbestos panels: TOP PANELS 'Nativity' , BOTTOM PANELS 'Descent from the Cross'.**

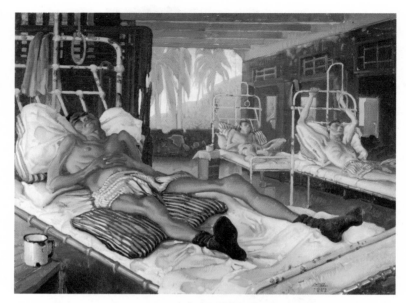

Three Australian POWs lying in hospital beds. [Griffin, Murray. Roberts Hospital Changi 1943, oil on hardboard, 64 x 82.1 cm, AWM ART24491]

the growing shortage of food coupled with few medical resources and major sanitary problems meant that the men's health rapidly declined. British rations had gone, and now the men were on Japanese rations mainly consisting of rice. Red Cross parcels were not allowed by the Japanese to be distributed, thus exacerbating the situation. Dysentery became a major problem and many men died because of it.

When the need arose to separate the malaria cases from the prisoners suffering from Bacilliary dysentery, the Post Office hospital was abandoned and the service moved to S Block of Roberts Barracks. By the end of March, with the incidence of dysentery increasing rapidly, it became necessary for the formation of a separate dysentery wing which was established in Block 15l.

W. Brand was an officer of the Royal Army Medical Corps serving in the dysentery wing. He remembers: "The laboratory established itself on the ground floor in a room next to what was a QM

(Quartermaster's) storeroom.... When the dysentery wing started in March 1942 there was no running water and no sewage system working. Exudates from the dysentery wards had to be carried to fly-proofed Otway pits. Although water was partially restored in 1942 the sewage system remained out of order.

"There were many deaths and those who recovered soon found themselves on Japanese work parties. All was not plain sailing, just as the dysentery wing was getting the upper hand of the dysentery epidemic, large numbers of Dutch troops from Java and Timor suffering diarrhoea were admitted into the hospital and were a further strain on resources."

On 23 May 1942, Stanley Warren – lying comatose with a red cloud over his eyes – was moved from Bukit Batok to the Roberts Barracks hospital in Changi.

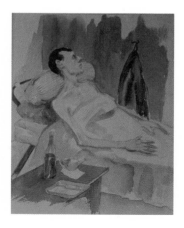

Stanley Warren's painting of a fellow patient – a dying Dutchman. He later recalled,"I was watching the man dying and I put that down as a kind of personal note, not as it were to reveal the sort of treatment."

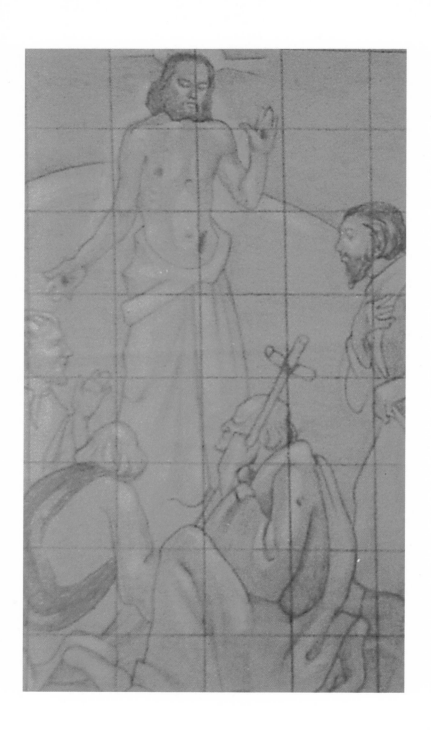

4 | The Painting of the Changi Murals

THE BRITISH ARMED FORCES have for many years had their chaplains, fondly called 'padres', with them in times of peace and war. Often these priests performed acts of heroism, and like Woodbine Willie in World War I, become well known outside the forces. Others, though unsung, performed their duties well, and gave their flock the spiritual uplift they desperately needed. Three of these padres were the Reverends F.H. Stallard, G.I.M. Chambers and J.N. Duckworth. They had found themselves taken prisoner and were serving their fellow captives in Roberts Barracks.

Padre Stallard negotiated with his captors for a chapel, and was eventually given permission to create one. From the dysentery wing he converted an end ground floor room of Barrack Block 151. The chapel was dedicated to St Luke the Physician, an appropriate choice, given the use Roberts Barracks was being put to.

The chapel was fitted out with whatever suitable furnishings were available, or could be made by the prisoners. A number of wooden benches were found and a lectern was made by some officers. For the altar, which was placed on a dais, rails were made. Even a harmonium was found and installed to provide music. The walls were bare and coloured with a distempered finish which Stanley had described as "old gold."

Section detail of Stanley Warren's draft for the Ascension mural.

W. Brand remembers: "The chapel was quite a pleasant and simple affair with a wooden altar and benches, with a harmonium against the right hand wall looking from the entrance. A variety of nationalities and denominations made use of the chapel and harmonium, but I most clearly remember Len Cheetham of 198 Field Ambulance who played regularly. The music was a welcome background to our rather tense existence in the laboratory."

By the middle of August, Stanley Warren had recovered enough to be moved to the dysentery wing at Block 151. "There for the first time I came in contact with the chapel. I heard the choir singing," he said. It was a beautiful choral litany.

Padres Chambers and Payne had heard that Stanley had decorated the prisoners' chapel at Bukit Batok. So they asked him if he would paint murals for St Luke's Chapel. Stanley agreed and requested that he be supplied with the dimensions of the chapel walls, and with painting materials. He sought inspiration for his work in the Gospels, reading all four of them and, "selecting the texts which would form the basis of a coherent group of paintings."

On 30 August 1942, at the time when Stanley was making his selection and was preparing the draft drawings of the murals, the Japanese began an action which would became infamous as the Selarang Barracks Square Incident.

The Japanese instructed the POWs through Colonel Holmes to sign a 'No Escape Pledge' stating, "I, the undersigned, hereby swear on my honour that I will not, under any circumstances, attempt to escape." This was shortly after the recapture of four escaped soldiers, Australian corporal Breavington, and British privates, Fletcher, Gale and Waters. This type of declaration is against the Geneva Convention, and Holmes and the POWs rightly refused to sign. The Japanese response to the refusal was to have the four soldiers executed on Changi Beach on the morning of 2 September.

At midday, the Japanese issued an order for all prisoners in the Changi peninsula to assemble in Selarang Barracks Square. The only

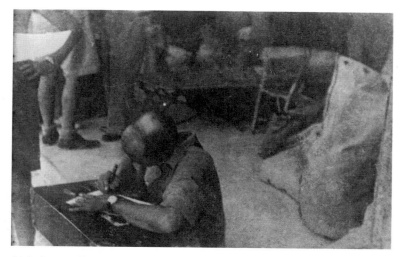

At Selarang Barracks, a POW signing promise not to escape – under orders, September 1942.

Cookhouse, Selarang Barracks, September 1942.

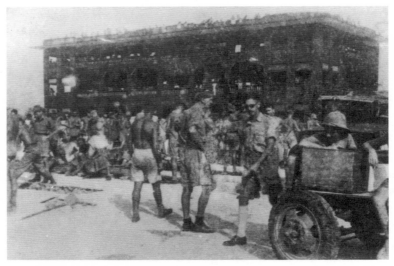

Latrines in the centre of the square, Selarang Barracks, September 1942.

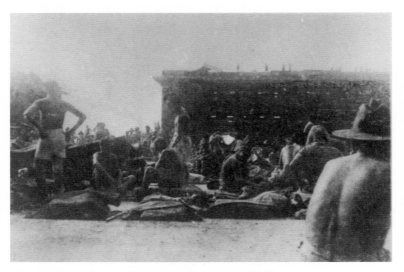

View inside Selarang Barracks, September 1942.

Australian MI Room, Selarang Barracks, September 1942.

View inside Selarang Barracks, September 1942.

A rainy day at Selarang Barracks, September 1942.

Australians in Selarang Barracks, September 1942.

exception to the order was the men in the hospital area at Roberts Barracks. All the POWs had to be in Selarang within five hours. By the evening, some 17,000 men were crammed into the eight buildings and area in and around the drill square at Selarang. Were it not for the work parties which had been sent away from Changi, the situation would have been far worse. As it was, sanitary provision for such a large number of men was totally inadequate, and food and water was in very short supply, with only a couple of taps available to the multitude of prisoners. On 5 September 1942, the senior POW officers succumbed to the Japanese orders to sign the declaration. The Japanese had threatened to bring sick prisoners from Roberts Barracks to the square. The consequences of this action would have been unthinkable. With so many people crammed into the area in extremely unsanitary conditions, disease would have rapidly spread through the weakened men. The order to sign 'under duress' was given, and the prisoners signed the declaration, many giving false names. The men were then sent back to their respective parts of Changi.

<p style="text-align:center">* * *</p>

Against this backdrop, Stanley Warren began to paint the Changi Murals. No one had asked the Japanese for permission to draw the murals. And at no stage did they interfere.[1]

From the start, Stanley's mural project captured the interest of his fellow prisoners. W. Brand recalls, "With a sheaf of drawings on tracing paper, Warren carefully copied the images on the paper to the chapel side of the laboratory wall."

Suitably coloured paint was not readily available in the camp, but with the aid of other prisoners, who unquestionably put themselves at great risk, materials to make the paint were gradually acquired. Turf-brown camouflage paint was brought to Stanley, as were a very small tin of a "violent crimson," which he thought was a really terrible colour, and a tin of good quality white oil paint. Six cubes of

billiard cue chalk were crushed and used to produce blue. After the first mural was completed, a large drum of grey paint was scrounged and added to Stanley's palette. Brand thinks that colours were also obtained from paint scraped from a variety of scrap, including cars and lorries.

The technique Stanley used was that acquired when he worked as a cinema billboard artist at Grenada. He drew in clear bold outlines so that the murals could be seen at a glance or from a distance. To compensate as much as he could for the lack of available colour, Stanley resorted to large brush strokes and areas of solid colour. The result was to be murals of very low tones.

Despite still being ill, Stanley began work on the first of the murals in early September 1942. His illness meant that he could only paint for a limited period each day, and then only for perhaps 15 minutes at a time followed by a rest – lying down behind the curtain of the chapel altar.

The progress of the murals was followed with interest by the prisoners and some of their captors. Stanley recalled: "The Japanese soldiers would come in, the Japanese sergeant and Korean guards. They would sit along the wall ... [and] press their rifles on the wall. They would look on and never interfere. [The chapel altar was] decked with frangipani blossoms cut from the trees that did grow within the POW area, they gave out their fragrance, and it always seemed cool ... and the men would sit quietly on the benches, often discussing home, discussing family affairs. They would also follow the progress of the murals and trade stories about the artist!"

And what stories they were! Some said that he was a sinner – a very violent and terrible man who had been reformed. Others said that the murals were a thanksgiving for his recovery from severe illness. There was even one beautiful legend of how nuns were smuggling eggs through the bared wire so that the egg whites could be used for temper painting. It was said that the unfortunate women were caught in the act, captured and shot.[2]

Considering the purpose of the murals, Stanley decided to "make something which was at once different from the environment," with "no expression at all of the brutality, the squalor of the surrounding area," something which would give "total relief." He felt that the chapel was basically dedicated to peace and reconciliation and so he chose universal themes for the murals which would embrace all mankind. Although he had this larger scheme in mind, he thought about one mural at a time. "I didn't know whether I [would] live to complete the mural I was working on or live to complete the next one."

Altogether, Stanley produced five large murals on the side walls of the chapel. His tools for this great work were the scrounged paint, paint brushes (some put together using human hair) which ranged in size from a large one for filling in big areas to a small Chinese calligraphy brush for delicate work, two ladders and a plank. He began to work quite slowly because of his illness and meagre diet. "If I started at 9; by 11 o'clock I was always fainting.... It would be really unsafe to try to climb a ladder. So obviously I had to work slowly." The surface of the walls presented Stanley with a major problem. The types of paint he had were not really suitable for a distempered wall; the wall, being very absorbent, acted like blotting paper absorbing the paint. Stanley used bold sweeping strokes wherever possible, followed with a dry brush technique to mottle and give some depth to the painted surface. The sweeping strokes were necessary as, if he had stopped when using the oil paint, an oil stain would have spread out onto the distemper. This could not be scraped off, as a bare patch would be left on the surface of the wall. "So this was the technical difficulty that one had to surmount throughout the painting of the murals," he recounted.

On one wall he painted 'The Nativity' and 'St Luke in Prison', each mural being about three metres long. On the other wall are 'The Last Supper', 'The Crucifixion' and 'The Ascension'. All are subjects which are at the very heart of Christian belief. The pleasure and spiritual uplift these murals must have given to the POWs worshipping

or praying quietly in the chapel can only be imagined.

The first mural to be completed was that of the Nativity, or birth of Jesus Christ. "It isn't, curiously enough, an ... impassioned work. It is gentle and full of humour. I wanted it to be so." Stanley painted each of the three kings who presented gifts to the baby Jesus as being from different racial groups. The figure holding the cup is oriental, the robed and turbaned kneeling figure at the front is Middle Eastern, and the third figure is northern European, "Slav or Teutonic, somewhere from the north." Had tradition allowed a fourth king, Stanley would have made him African, "so that there was a concept of universality." The old shepherd has his lips pursed, cooing at the child, and the animals, except the red calf, are moving towards the infant Jesus in the crib. The calf has somewhat irreverently begun to move away, but as if by afterthought has turned its head to the crib. The ox is not as might be envisaged by a European, but has the hump characteristic of the Asian variety. St Joseph is seen throwing his hands in the air as if in astonishment. "We all laughed at that, including Padres Chambers and Payne," remembered Stanley. The Madonna is portrayed in quite a traditional manner, unlike the Malay Madonna he had done for the chapel at Bukit Batok: "I wanted it to be a familiar figure to the men who had seen stained glass...." Stanley concentrated his effort on the head of the Virgin, working on expressing the greatest tenderness possible from the harsh media he was using. "I [had] almost eliminated all line work down to the absolute barest and just working with the white patches to model up the face as gentle as a young mother would be." In the end he was satisfied that the refinement he achieved was the best he could do under the circumstances.

Stanley did not always agree with Padre Chambers during the painting of the murals. The first disagreement was about the inscription

PAGES 59-62 The restored murals showing the Crucifixion, the Nativity, the Last Supper, and the Ascension. PAGE 63 The original mural of St Luke in Prison, and Stanley Warren's 'restoration' – a small painting of the entire mural.

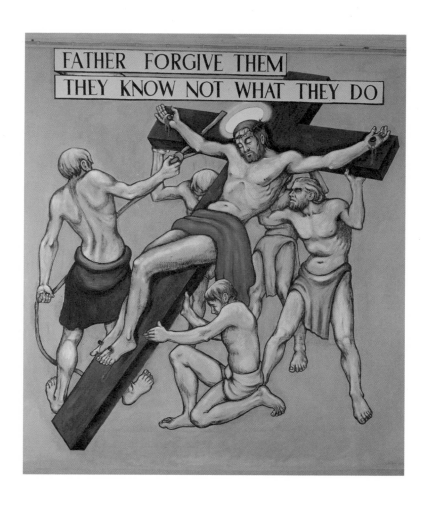

PEACE ON EARTH TO MEN OF GOODWILL

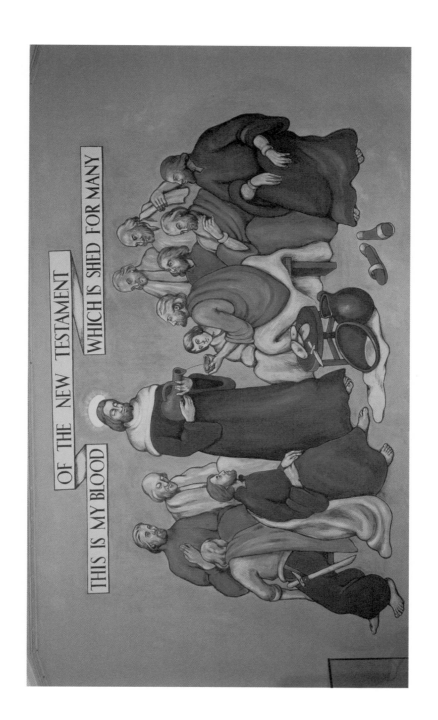

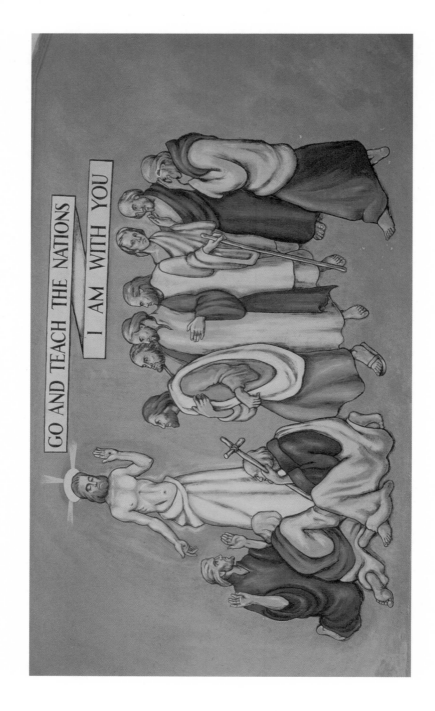

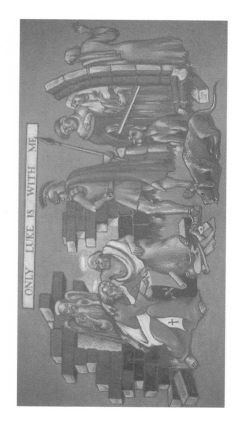

for the Nativity mural. Stanley preferred the text from the 1611 Authorised or King James Version of the Bible, "On earth peace, goodwill to all men." The padre, however, was most insistent on the Vulgate Translation, which gave the verse as "Peace on earth to men of goodwill." Stanley felt that the Vulgate Translation opened up the option of deciding which were men of goodwill and which were not. This, he felt, went against the message of universal brotherhood he wanted to convey. Artist and priest argued over the interpretation for days, so fiercely that the padre was reduced to tears. In the end, Stanley gave way, and the words from the Vulgate Translation were used. (See *Appendix 2*)

Very ill with dysentery, and thinking that he might well die, Stanley desperately wanted to complete this mural in time for Christmas. "When that mural was finished, I was taken upstairs into the ward immediately above. And from there I heard the great Christmas service of 1942. All the carols ... the chapel was absolutely packed. And outside, all along the verandah and on the path ... the prisoners were listening to the hymns."

After Christmas, Stanley's health improved fairly quickly and he was able to start work on the second mural: the Ascension of Christ. The mural shows the risen Christ saying to his disciples, "Go and teach the nations. I am with you," which continues the universal theme of the murals. Stanley decided to paint this mural after 'The Nativity' because he thought that if he should die before all the murals were completed, the two murals would show the beginning and end of Christ's time on earth. He felt that this was important.

The Ascension mural, which Stanley said was the most freely painted of the five, was completed "at a fairly high speed ... possibly two or three weeks." The result is an exhilerating freedom in the movement of St Peter going forward towards Jesus, with the other disciples milling around. Stanley thought about the portrayal of each figure carefully, since he wanted to show the individuality of each apostle, including his weaknesses and failings. The artist explained,

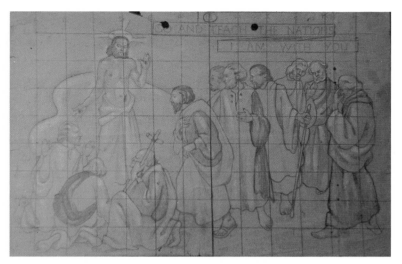

Stanley Warren's preliminary draft of the Ascension mural squared up for enlargement.

"For example, St Peter is going forward to the risen Christ, hand on his heart, remembering that he had denied Christ three times. St John, the third figure from the right, was very jealous of his special place of favour with Christ, and he is looking at us slightly aggressively, as if telling us to keep our distance. The figure on the extreme right, of course, is Thomas, the doubting Thomas. He's covering his face with his hands, remembering that he had said. 'Not until I put my hands into his side and my fingers [in] his hand [will] I believe he has risen.'"

The third mural to be painted was the Crucifixion. To keep the scale of the figures uniform in the limited space, an oblique design was used for the cross. Stanley deliberately chose slaves to carry out the crucifixion, "after all, we don't know the full details of who crucified Christ, merely, 'they took him and crucified him'." The slaves, clad only in loincloths, were a direct reference to the prisoners' own condition. By using slaves, he was also inferring that the Japanese soldiers were under orders when they carried out the many atrocities they committed. Sometimes unwilling Indian troops were used to

65

carry out executions and torture under Japanese orders. They, like the slaves depicted, had to do what they were told. The slave on the right of the cross is compassionately looking up at Christ on the cross as it is raised. He is feeling real sorrow and regret as to what he is being forced to do. As a committed Christian, Stanley was, in this mural, forgiving his captors for the mistreatment of POWs. "I'm glad I felt able to do that," he once said. He also recalled that the Japanese guards were very interested in this mural, coming regularly to watch its progress. "Probably they knew, obviously they knew, what it was all about, even if they didn't understand the words 'Father forgive them, they know not what they do.'" He also explained that he had painted Jesus' eyes closed as he felt that he had not the impertinence to look into eyes of Christ.[3]

The theme and design of this Crucifixion mural were so powerful that when the chaplain held small services in the chapel, he chose to put his lectern immediately under it.

Next came the painting of the Last Supper. Stanley was by now almost completely out of blue paint – he had just enough to use in a couple of places. He said that although this was the "most personal" of the murals, he did not feel that it was an exciting one. The mural depicts Christ giving the very first Sacrament of Communion to his apostles before his betrayal by Judas Iscariot, and his subsequent torture and crucifixion. The inscription reads "This is my blood of the New Testament which is shed for many." Christ was telling of the suffering and death which he would soon endure. Stanley portrayed Christ as a towering figure like the lighthouse on the small rocky island of Pulau Pisang where Stanley had operated an observation post. He painted Christ with a white cape and halo resembling a lighthouse with the lamp illuminated. The apostles and the table, jug and bowl were representative of rocks. "The table was in one of the billets of the RAMC and the jug and the circular basin were replicas of the aluminium ones that we used in the ward to wash down bedridden patients. And the sandals were my own. In a sense

it was a sort of personal signature."

The final mural, which depicts St Luke, was painted at the request of Padre Chambers. It shows an aged St Luke in prison, writing his gospel for the fledgling Christian community. He has St Paul by his side and an angel behind him. He is assisted by a boy holding a sheaf of paper rolled up like the Horn of England. A Roman centurion stands guard. The walls of the prison are broken down and the bars are bent to show that the spirit cannot be contained. Christ's word would go out to the world despite imprisonment. Stanley had in his mind the words of the poet Richard Lovelace, "Stone walls do not a prison make / Nor iron bars a cage...."

Of all the murals, this was the one least liked by Stanley. He not only felt that it was far too heavy and grey, he did not want to paint it in the first place.

Stanley would have preferred something more in keeping with the theme of the other murals, a scene from Christ's active ministry, perhaps. Padre Chambers, however, was insistent that St Luke should be depicted in the chapel which was named after him. Stanley was sad that the padre imposed his views, and felt that this cast a slight shadow in their relationship. He offered to paint St Luke raising a sick man, but the padre rejected this as being too close to the situation of the prisoners in the hospital. Stanley understood.

"So often, Padre Chambers walked with me and said, 'You know, it's so hard to try and persuade men to live.' When you look at the suffering, you think death would be a most merciful release.... I know at times he was quite heart broken in the fact that he could do nothing except say a few kind words and give such comfort.... [The padres] were able to retain a standard ... a civilised conduct. Men were so accustomed to death as to become callous, almost totally callous. You know, a body would be thrown into a hole dug without even a service, without dignity. And of course the Padre strove to keep both spiritual and human values. In this way, of course, the church played an important role in survival and stopping men from

becoming so totally changed, transformed. As much as the murals contributed to that, I was glad."

The Changi Murals were completed by May 1943. Stanley said that their effect on the atmosphere in the chapel was quite over-whelming, as if they were pressing in on you. To W. Brand, "It was remarkable how the murals took a life of their own." The chapel itself was quite dark as there were only windows and doors at each end of the long room, although light was reflected up from the floor. At night, lighting was provided by eight lamps with porcelain shades hanging on flexes from the ceiling. Sometimes, services were held by candlelight. This meant that the uppermost portions of each mural were never fully lit. This is why Stanley put the banner inscriptions at the top, so that the figures in the murals would be seen at all times.

Painting the murals was a spiritual experience for Stanley War-ren. During the course of the work, he would occasionally rest his head against the wall and "converse with God." Although he did not get a reply, he said that "at times I was so elated that I felt I was spoken to. Elation – the word that describes the actual experience of painting the murals. The strength to work on the murals was of a religious experience, an ecstasy which I had not known before and to that extent never to know again."

Notes

1. Although the guards did not interfere with the painting of the murals, they did put a stop to one of his other works. Stanley started to draw a map of Europe on the wall of the officers' mess and was prevented from doing so. The map was to allow the officers to follow the progress of the war received on the clandestine radio sets in the camp.

2. Commenting on this story years later, Stanley Warren said, "I don't know if they did in fact shoot any nuns, but it certainly wasn't for smuggling eggs to me. I had never received any eggs… and had I got my hands on the eggs I would have eaten them!"

3. Among the prisoners who came to observe the painting of this mural was Major Osmond Daltry, the officer responsible for training when Stanley Warren enlisted in January 1940. The major had lost an eye and a leg in the fighting, yet his words to Stanley were, "Hello, Bombardier. Good job you know your anatomy." Stanley thought that it was so typical of Daltry – that despite all that had happened to him, he retained a wonderful sense of humour.

Sketch of a Japanese or Korean guard by Stanley Warren.

5 | Surviving the War

AFTER COMPLETING THE MURALS Stanley had a short period of improved health before being taken gravely ill again. He suffered a severe form of dysentery and haemorrhaged badly. He became paralysed and spondylitis affected him. It was thought that he would not survive. Indeed he was so ill, he thought that he really wanted to die. Prayers of intercession, led by Padre Chambers, were said for him before the mural of the Crucifixion.

"After weeks of being very, very seriously ill, I slowly recovered and I was able to walk into the chapel again."

In another way, the painting of the murals may well have saved Stanley's life. In late September 1942, a few weeks after he began painting the murals, he was well enough to be released from hospital and return to his unit. Each morning, he would cross from the general prisoner-of-war camp to Block 151 and work on the Nativity mural. During this time, his unit was to be sent north as a work party. One day, he was confronted by the colonel in charge of the hospital area. "I'd never seen him in the chapel … [but] he stood up … and said, 'Well, Warren, you've got to complete the murals. I am going to ask for you to be transferred back to the hospital area. I think I'll have a word with the officer there, your Commanding Officer, Major Peacock. He will advise you in the same way.' So Major

Peacock called me and said, 'I don't think you will perhaps survive the rigours of the north. Come back.'"

Most of Stanley's unit who went to the Thai-Burma railway never returned. "Had I gone with them, most certainly, I would have died. So the murals very directly saved my life [in] the way I could never have foreseen.... It's a terrific sense of debt ... that one feels to the chapel."

* * *

The chapel had a relatively short usage by the POWs because, in May 1943, the Japanese decided that the area to the east of the camp would be ideal location for an airfield.

The Japanese needed accommodation for their air force personnel and airfield construction engineers, also space for storing equipment necessary to the building of the airfield. First to be affected were the men in Kitchener Barracks. They found themselves packing what few belongings they had and moving to Selarang. Roberts Barracks was unaffected by the move and remained as the prisoners' hospital.

From the hospital, Stanley could see, in the distance, parties of prisoners working on the airstrip. "[They] were uprooting trees, the coconut palms ... they were having to hack at the roots and dig them out."

In May 1944, Roberts and Selarang Barracks were taken over by the Japanese as well. Block 151 with St Luke's Chapel's inspiring murals was designated to become a store. The mural of St Luke in Prison was almost completely destroyed when the lower portion of the wall it was painted on was demolished to make a link to the adjoining room. The walls of the chapel were distempered over, hiding the murals from view.

All the prisoners in Changi Cantonment classified as fit by the Japanese were moved to Changi Prison. Those classified as sick, some

Changi airfield, not long after the war, taken over by RAF.

1,200 men, were sent to Woodlands in the north of Singapore island not far from the causeway to Malaya.

At the time of the move, there were approximately 12,000 POWs living in Changi and Selarang. Of this, some 5,000 managed to cram into the prison itself, the remainder lived in attap huts outside the prison walls. The huts had all to be built by the POWs, as did additional shacks within the prison walls. No help in the construction or supply of materials was given by the Japanese. At the same time, survivors of the Thai-Burmese railroad were brought to Changi along with Dutch, American, and, surprisingly, Italian POWs. These Italians were the crew of a submarine which, unfortunately, was at Singapore at the time of the Italian surrender to the Allies. Changi Prison was packed beyond its limits, while Changi Cantonment was now devoid of prisoners.[1]

For two years, POWs had to walk every day to the airfield construction site north of the prison. Their work was backbreaking as they had only rudimentary tools and equipment. First of all, the area had to be cleared of scrub, levelled, and swampy areas had to be

POWs at work.

POWs at work.

drained and filled in. A railway system was constructed to move spoil and rock. Small trucks were filled by hand and pushed along the tracks, strenuous work even for a fit man, but the work was done by half-starved, sick men in the searing heat.

Once a suitably large area had been prepared by the prisoners whom the Japanese called a 'levelling party' as a concession to the Geneva convention, two landing strips were constructed. One strip was roughly on a north-south bearing to the east of the Johore Battery and POW cemetery. The other was on an east-west bearing, and crossed the other strip just to the north of the remains of the most northerly Johore Battery gun, and the cemetery. As well as the airstrip, the POWs had to construct airfield buildings.[2]

Stanley Warren and Padre Chambers were among the POWs moved to Kranji. In spite of being on the seriously-ill list and not being expected to live, Stanley was able to walk into the chapel, help stack up furniture which was to be taken away, and see his murals for the last time.

Concert programme poster by William Haxworth, 1942.

Australian POWs performing a concert for their fellow prisoners on the stage at the 'Command Theatre' in Changi, c. 1943. [AWM PO1433.010]

The quality of life for the POWs seemed to fall in Kranji although there were remarkable efforts in providing entertainment and lectures on various esoteric subjects.[3] Stanley Warren took a less active life in the prison community and turned inwards, spending time studying Greek history, drawing, and thinking about personal survival. He was very worried about how some of his fellow prisoners lost their minds. "I thought it was a fight against insanity if you could really keep your mind occupied.... If I was going to survive, I was going to survive as a person, not a vegetable." According to Stanley, Padre Chambers was "almost like a lost soul."

By the time the first aircraft flew from Changi in late 1944, the war was going very badly for the Japanese and the prisoners knew it – not only from their hidden radios, but from the evidence of their own eyes. Allied reconnaissance aircraft would often be seen flying over Changi, and the noise of bombing coming from the naval base area could be heard in January and February 1945. Air raids also struck the docks and following these, the Japanese further reduced the starvation rations the prisoners were on. British forces led by Lord Mountbatten were now sweeping through Burma towards Rangoon. The Japanese were preparing for their defence of Singapore and able-bodied men from the Kranji POW camp were detailed to dig fox-holes, tunnels and defensive positions in the north of the island. Ironically, with their clandestine radio sets, the POWs were kept abreast of the progress of the war while their Japanese guards were totally in the dark. "And our difficulty was I think, in suppressing the excitement or the anticipation," recalled Stanley.

Stanley felt that there would be fighting when the end came. Anticipating a massacre of prisoners, he had studied the perimeter of the camp and decided that it was possible to "make a break and hide in the Kranji swamps ... and hope that British troops [would] come along."

Padre Chambers asked to be transferred to the able-bodied section of the camp. In July 1945, while intervening between a Japanese guard who was beating a prisoner, the padre himself was beaten

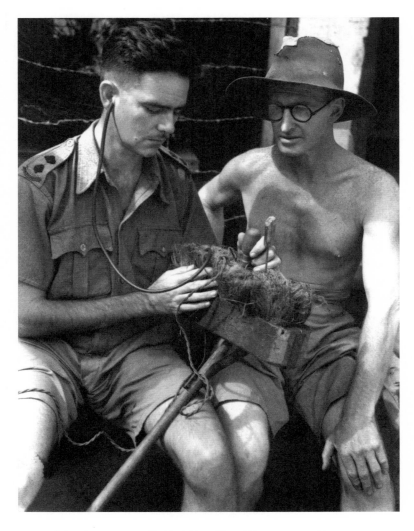

**Many ingenious hiding places for radio sets were constructed to foil
regular Japanese searches.The famous 'broom' wireless set of
Changi Prison, examined here by two Australian POWs in 1945, was
never discovered by the Japanese.** [AWM 117006]

up, sustaining severe internal injury which resulted in his death. Stanley said of his death, "He was an ageing man, and was out with a party of prisoners.... And one of the prisoners was being beaten because he couldn't drag a basket of stones. And he was really being badly beaten up. So the old man rushed forward, you see, and tried to help him with the basket. And then he [also was beaten until he] collapsed with internal haemorrhaging." The padre was taken to one of the huts and pleas were made to the Japanese for him to be taken for an operation, pleas which fell on deaf ears. During the night a medical party from the hospital came into the camp under the wire, carefully avoiding Japanese patrols. "They took a hurricane lamp with them and they operated on the poor man in one of the huts with just a chloroform pad over his nose. But sadly ... they could do really nothing.... The poor man died very quietly, very bravely." [4]

On 15 August 1945 came the news that the surviving prisoners had long hoped for – Japan had surrendered. The prisoners found themselves in a quandary for they had learned of the surrender from their clandestine radios. The Japanese themselves did not tell them of it. It was two days later on 17 August when the Japanese admitted that the war was indeed over. They then recalled all working parties to the prison. Despite the Japanese surrender, the now ex-POWs would have to wait for relief as Allied forces were still some distance from Singapore. Stanley Warren remembered, "When the final wrap up came ... the guards seemed very confused. The planes had bombed our camp with leaflets in Japanese warning them what would happen, [that] they were held responsible for the prisoners. And now we got a strange period when the prisoners walked around the camp, and the guards just took no notice what they did, but they remained at their post."

At Changi Prison, the prisoner's lot was lightened by lorry loads of food and clothing brought in by the Japanese on 23 August. On 30 August, supplies accompanied by some medical officers were air-dropped onto Changi airfield. It is perhaps ironic that despite all

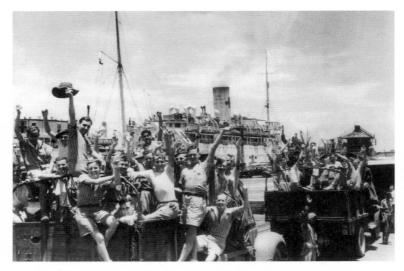

Two happy wagon loads of released POWs give the photographer a cheer as they drive in to board hospital ships for treatment and evacuation following the Japanese surrender, September 1945. [AWM SUK14747]

their work on the airstrip, the POWs' first relief was parachuted in, not landed. It was another six days before the first Allied troops arrived at Changi. On 5 September, the 5th Indian Division arrived outside the prison to find some 17,000 men waiting for them.

While waiting for the arrival of Allied troops, the POWs at Kranji watched Japanese troops marching past their camp. Stanley said his comrades were sitting on planks laid over the trampled barbed wire watching the spectacle. "They were sitting there, smoking cheroots … really laughing … joking at the Japanese, almost sneering at them – a great joke. They did not seem to notice that everyone of the Japanese troops were armed to the teeth and could have loosed rounds at them in hysteria. I was a bit more imaginative, perhaps, than my fellow prisoners."

In the end, a beautiful thing happened at Kranji when the POWs were freed. "A lot of the local girls, the local population came to the camp with flowers. It was quite unbelievable, you could absolutely have cried, the girls came with flowers."

Their ordeal was finally over, although men continued to die from the treatment they had endured under the Japanese. Many prisoners would carry the mental and physical scars of their anguish for the rest of their lives.

For Stanley Warren, he believed that his murals had been destroyed by Allied bombing towards the end of the war. "I was told that one or two [POWs] went back to Changi, and they'd said the chapel had been totally destroyed, everything eliminated, everything wiped out." He could not bring himself to go and look at the remains himself.

Notes

1. The surviving civilians at the prison were moved to Sime Road Camp where they continued to suffer and die.

2. These were in use for many years after the war. The author actually worked in a Japanese hanger when he was at Changi during the period 1967–68.

3. In an oral history interview, Stanley Warren recalls a concert: "[T]he Japanese said, 'Well, you have got a band ... we want a concert, can you play some Japanese songs?'.... And so the day of this concert arrived. In the march, the Japanese, you see in front seats ready for hours. So of course, the orchestra struck up with the Japanese national anthem. And then went straight on to the British national anthem. The Japanese were not prepared for it and do you know, they stood, they continued to stand during the British national anthem. It was very, very funny."

4. Padre Chambers is buried in Kranji War Cemetery. He had often hoped that Stanley would paint some murals in his church in Hampshire after the war.

6 | The Rediscovery of the Murals

THE ROYAL ENGINEERS returned to Changi once the Japanese, now prisoners themselves, had been moved to camps elsewhere in Singapore. The boot was now on the other foot and the Japanese were put to work clearing up Changi and further developing the airfield. Their conditions of work were far better than those of their erstwhile prisoners and they were much better fed and treated by their captors. There was much clearing to be done as, despite being at Changi since 1942, the Japanese had left much work undone. The remains of the gun batteries even had ammunition buried in the debris.

The British military soon concluded that there was little future in rebuilding Changi as a coastal artillery base, but the airfield could certainly be put to good use. In 1946, the British Army leased the camp area to the RAF. The RAF had been using Kallang airfield since their return to Singapore, but the volume of air traffic was proving to be too much for Kallang to cope with.

Once firmly ensconced at Changi, the RAF also found work for the Japanese prisoners. They found that the runways were in poor order and required strengthening. The RAF got the Japanese to build a temporary PSP (pierced steel planking) runway on the north-south landing strip, and a taxiway parallel to the northern part of the new PSP strip.

Block 151 of Roberts Barracks today. St Luke's Chapel is at the far end of the ground floor.

In Block 151, St Luke's Chapel was again used as a store, and later for accommodation, this time by the RAF. The murals still lay under their covering of distemper.

When W. Brand visited Roberts Barracks after the war, he found that Block 151 housed a number of national service recruits of the RAF. "Their beds were strewn about untidily wherever they felt like having them, some in the area that had been the chapel. The wall where the harmonium stood had been removed by the Japanese, but the murals were intact apart from the one damaged when the Japanese had breached that wall to join two rooms.

"The young national servicemen, when I questioned them, had only the vaguest idea about the murals. They were unaware that they were in what had been a chapel, and again [had] only the vaguest idea that there had been a hospital and a large body of prisoners of war in the area. The RAF administration itself did not seem to have much knowledge of the history of the area. The young airmen told me an interesting story; they showed me or pointed out one bed space, not in the former chapel area, where they said no one would sleep because it was haunted. A number of chaps had tried but all had been frightened by something. I had no explanation. Had it been a space or two on the first floor where I knew some POW died in agony I might have wondered.

"The barracks generally, and what had been the dysentery wing appeared much the same as when we had left them. There were square patches of brilliant green grass where once the Otway pits were. They were close by the chapel. Barbed wire still lay about, rusty and broken, and bomb damage to the buildings could still be seen."

Interestingly, there are two official stories concerning the so-called 'rediscovery' of the murals in 1958. One is that an unnamed RAF national serviceman was told to clean up the storeroom which had served as the POWs' chapel. Fortunately for posterity, this serviceman on discovering that some paintings lay under the distemper, reported his finding to an officer, who, on examining the paintings,

realised the importance of the discovery. The second story is that the murals were discovered by three members of the Singapore Armed Forces (SAF) working in the storeroom.

Stanley Warren, c. 1982.

Once rediscovered, the distemper coating covering the murals was carefully removed – four complete murals and the top quarter of a fifth were revealed. There was no signature on any of the murals, so the identity of the artist was a mystery. A search for the artist was started, but all initial investigations failed to unearth the wartime artist. An all-out search was then put into operation. In the same year as the 'official' stories give, the RAF Changi magazine *Tale Spin* printed pictures of two of the murals saying they had been painted by an unknown POW during the Japanese Occupation of Singapore.

Some people suggested that the murals were painted by Ronald Searle, the well-known artist and cartoonist. He had been a prisoner of the Japanese, and had in fact painted some murals, twelve feet in height in Changi Prison. When asked about them, he said that he had not painted the Roberts Barracks murals. The trail was still cold, but efforts to find the artist continued. A letter from a young lady in Singapore was printed in the 'Old Codgers' column of the *Daily Mirror*, a popular British newspaper, along with one of the *Tale Spin* pictures of the murals. The letter drew a large response bringing many theories, but still no positive identification of the artist. The *Sunday Times* of Singapore had meanwhile also been searching hard but with no better result.

Surprisingly, the artist's name accidentally came to light in Singapore, in the RAF Changi Education Library of all places. A browser came across a book entitled *The Churches of the Captivity in Malaya*. In the book was an article about the Chapel of St Luke the Physician in Block 151 Roberts Barracks. The article, also illustrated by a sketch

of the chapel,[1] gave a description of the murals and also the artist's name – Bombardier Stanley Warren.

The *Daily Mirror* was notified and again went to work looking for the now known artist. In February 1959 Stanley Warren was finally found living in London with his wife and son. He had not given up art and was teaching the subject at the Sir William Collins Secondary School.

While all the searching was going on in Britain, The *Sunday Times* in Singapore also had some success. They had found Philip Weyer, a bank employee working in Singapore. Philip had been in the prison hospital with Stanley. He told the newspaper that Stanley was a quiet, religious man who had refused to sign his work despite pleas from his comrades. Stanley insisted that he had painted his pictures as a gift to God.

The 'official' stories of the discovery of the murals are similar enough to be the same tale, but both are incorrect. The murals may have been 'officially discovered' in 1958, and action taken to find the artist, but they had not been lost. They also were not in a storeroom, but in living accommodation and were visible long before 1958.

Kevin Blackburn, a university lecturer in Singapore, has documentary evidence from ex-RAF personnel of the murals being visible from 1947. I myself have been in contact with several ex-servicemen who saw the murals long before 1958.

In 1949, Neville Stubbings was serving in the RAF and was stationed in Changi. He was billeted in Block 151 and states that the murals were just visible under their distemper coating. 'Old sweats' would take pleasure in telling young servicemen like him that the pictures on the walls had been painted with prisoners' blood.

Brian Northover was living in Block 151 between 1951 and 1952. He was accommodated in the former St Luke's Chapel. The murals were visible and he actually made some enquiries about their origin and learned a little of their history. Brian believes that the murals

were distempered over again sometime after he left Changi and before their 'official discovery'.

William Fowler was living in Block 151 between July 1953 and June 1955. He remembered the murals as being exposed with one of them damaged.

Tony Lowe was billeted in Block 151 from April 1956 to February 1958 and, on his arrival at Block 151, the murals were exposed. Tony can remember visitors being shown the murals when he was there.

It is possible that the very existence of Stanley Warren's murals may not have been widely known throughout Changi Camp. As Block 151, including the chapel room, was being used for accommodation purposes, the importance of the murals had certainly not been realised. As such, servicemen being what they are, word of their existence may not have been widely spread. The 'official discovery' could have taken place after someone, perhaps one of the visitors looking at them, realised the significance and historical value of the murals and brought them to the attention of senior personnel.

Albert Peters served a two-and-a-half-year tour of duty with the RAF at Changi from January 1953 to June 1956. He was initially billeted in Block 151, then moved to Block 121. Albert, a practising Christian, joined the Changi Branch of SASRA, the Soldiers' and Airmen's Scripture Readers Association, eventually becoming Branch Secretary. He knew all the Chaplains at Changi, including the Principal Chaplain FEAF. Albert said that if "something of such a deeply religious nature and as significant as the Changi Murals, had been discovered during my two and a half years at Changi, I find it difficult to understand how my Christian friends and I didn't come to know about them. I would have thought that all three station chaplains and those at FEAF HQ would have known, and that news would have spread to those of us who were active in Christian work on the Station and others who were regular attendees at the three churches. It just seems odd to me that if the murals were discovered

before 1956 and people were coming to see them, that I was so oblivious to their existence." Perhaps, but God works in strange and mysterious ways.

Even after the murals had been officially discovered, the former chapel remained in use for accommodation purposes. It would be several years before the room stopped accommodating airmen and was returned to being a chapel.

One of these airmen, Peter Sanders, was with the RAF at Changi from 1961 to 1964. From 1961 until late 1962 he lived in the room that used to be St Luke's Chapel. His bed was opposite the mural of the Crucifixion. He found the words above the mural – "Father forgive them. They know not what they do." – "a sobering thought on waking up in the morning after a night out in Singapore!" The room was converted back into a chapel not long after he and his comrades were moved out of it, which was probably in early 1963. He went back to the room later that year to watch the murals undergoing their first restoration by Stanley Warren. Stanley told him that he had been very reluctant to return to Singapore, and that he was not sure if he would complete the restoration of all the murals as they brought back too many bad memories for him.

Note

1. Warren related how this sketch came to be made. "One day, a prisoner came to me in camp and said, 'Can you draw me a sketch of the chapel?' And he was so persistent. He was a church worker. Anyway, I drew this on a piece of old grey wrapping paper in a thick black pencil and a little white chalk… to silence this chap, so he'll worry me no more."

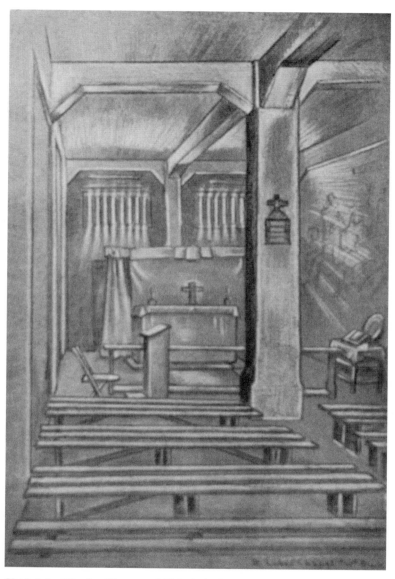

Sketch by Stanley Warren of St Luke's Chapel, Roberts Barracks, taken from *The Churches of the Captivity in Malaya*.

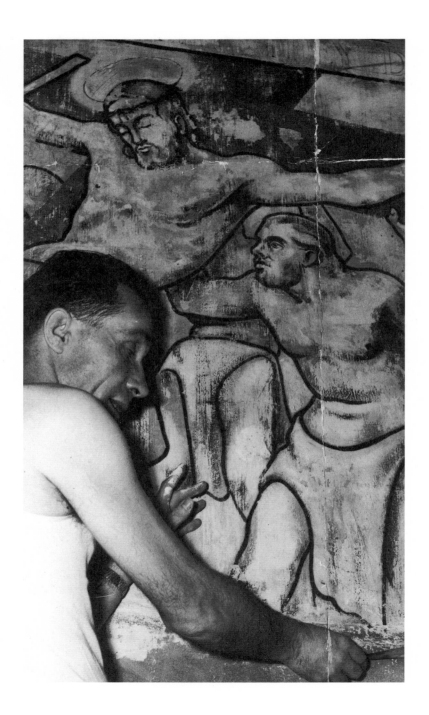

7 | The Restoration of the Murals

STANLEY WARREN WAS SITTING in the Staff Room of Sir William Collins Secondary School[1] in 1959 when a colleague reading the *Daily Mirror* said, "Do you know anything about this, you were a prisoner of war." Looking at the paper, Stanley was shocked to see a photo of his mural of the Crucifixion. He could not believe it. He thought that it was impossible for the murals to have survived.

During the early 1960s, the RAF contacted Stanley and the idea of restoring the murals was brought up. He was initially very reluctant to return to restore his work. He was afraid of all the terrible memories of war and captivity which the murals would bring back to him. "I didn't immediately want to come. I felt that there would be some sort of … trauma. I'm trying to forget this, you know, I tried so hard…. It took years really to eliminate the memories and fears … the long drawn out experience and really waiting for death over three and a half years, it's a long time to wait to expect death. And I really tried to forget…. But of course I was never able to do that."

Fortunately he overcame his fear and was persuaded to return to Changi to carry out the restoration. In all, he returned to restore the murals three times – December 1963, July 1982 and May 1988.

For the first restoration, Stanley arrived in Singapore in the dark in heavy rain just before Christmas, on 20 December. He remembered

Stanley Warren, restoring the Cruxifixion mural on his first visit, 4 Jan 1964.

the rain as being like the time he had first landed at Keppel Harbour those many years ago. In hand were most of the sketches he made for the painting of the murals as a POW. Once in the chapel again after so long, Stanley sat down and wept. He could see in his mind the terrible wartime scenes and the prisoners who died.

When work began, only three murals were visible: 'The Last Supper', 'The Crucifixion' and 'The Ascension'. Stanley was "absolutely amazed" by the state he found the murals in. Although the colour was beginning to peel, much of the original paintwork remained.

Stanley immediately realized that all the loose powder on the walls had to be removed as it could not be stabilized to provide a surface to work on. "So we carefully sponged the walls down, just removing the loose fine powder, fixed them with a polycell or one of the other ICI emulsions and then retouched them with emulsion paints."

The Crucifixion mural had been damaged where a door had been cut through the wall, and this had been roughly distempered over again. "So I had to draw in the feet of Christ [which] were knocked away and the lower limbs of the kneeling figure."

The Ascension mural had also been damaged. There was a line of holes along it where the wall had been drilled to fit shelves. The figure of Christ was faded and faint where paint falling from the ceiling onto it had been washed away.

On New Year's Day, 1964, SAC John Rankin of the RAF, who was assisting Stanley in the restoration, uncovered the remnants of the mural of St Luke. Much of it had been stripped off by the process of removing the eight layers of distemper which had obscured it. Also, the better part of the mural had been destroyed when a section of the wall was knocked down. At that time, Stanley did not have his original draft of the mural, so it was decided to leave the revealed section as it was. He felt that "it does show to some extent how accurate we stuck … to the technique [originally used to paint the murals] in the restoration. Nothing is being added to the restorations and nothing taken away."

So dedicated was Warren to the restoration that when he boarded the plane for this trip home, his hands were still covered with paint. He had worked up till the last hour before the flight took off.

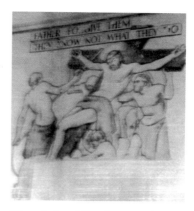

The state of the damaged Crucifixion mural before restoration.

Stanley's murals were discussed in the British Parliament in October 1968. Charles Morris, minister of parliament for Openshaw, asked the Defence Secretary, Denis Healey, to consider moving the murals to England. This was after the decision to withdraw British forces from Singapore had been made. Charles Morris kept the subject of the murals alive in Parliament. In November 1971 he asked about reproducing the murals in the Garrison Church at Aldershot. His original hope of bringing them to England had been dashed by an adverse report by the Ministry of Works in 1969. The idea of reproducing the murals, with Stanley Warren as the artist also fell by the wayside. Lord Balniel, speaking for the Government, reported that the Singapore Ministry of Defence had decided to take over responsibility of the murals and to keep them in good condition for display. In addition, a copy of one of the murals executed by Stanley Warren had been brought to England and placed in the Garrison Church at Larkhill in Wiltshire.

* * *

Stanley returned to Singapore again in 1982 to complete the restoration. This time, three boys from the SAF Boys' School and their officers assisted him. Quek Tin Boo, Lim Hock Peng and Ravi Sangra were fondly remembered by Stanley.[2]

The boys began stripping the wall on which the Nativity was

painted and the first section to be uncovered was the horse's head. The boys did a tremendous job, carefully and laboriously scraping away the layers of distemper, whilst Stanley applied himself to preserving the uncovered murals.

Stanley remembered the hard work put in by the boys. "I said to [Ravi], 'Please, take a rest!' And he got all the powder from stripping paint all over his face and body. And he just sat on my bed for a moment and then he simply rolled on his side and fell asleep.... He looked so exhausted. But nothing could stop Lim Hock Peng. He just went on and on till it cleared. He was working with both hands at times, lifting off pieces of paint with a paint scraper. He was determined to reveal the whole line."

On 17 July, the boys uncovered the original linework of the top half of the Nativity mural. The lower portion of the mural, however, had to be redrawn from Stanley's original sketch as it had been destroyed when that part of the wall was demolished and bricked up again. Still, Stanley was amazed that so much of the mural had survived after the treatment it had received. "I was absolutely staggered.... That's the ... story of their indestructibility." To restore the mural, the plaster on the newly bricked-up wall was removed and a half-inch plaster board was installed to bring the surface in line with the undamaged section of the old wall. After the gaps were filled with alasbastine and a coat of sealant was applied, the new surface was ready for the artist to work on. No grey paint was used in the restoration, as the original had been painted before Stanley was given the drum of grey paint 40 years before. "We must stick to the crimson, brown and white of the original. It must be, if it is not accurate, it is not history recorded," he said.

In uncovering the mural, the inscription "Peace on earth to men of goodwill" also surfaced. At that point, Stanley intended to surreptitiously change the translation to that of the Authorised Version – "On earth peace, goodwill to all men" – which he had wanted so many years ago. In the end, in deference to history, he restored the

mural with its original text. (See *Appendix 2*)

As he continued work on the restoration, Stanley noticed that the murals were damaged by drips of paint that came from the re-painting of the walls surrounding the murals. To prevent such accidents from happening again, he decided to remove the distemper from the walls around the murals and repaint them more permanently with the original old-gold colour of 1942.

One day, four SAF officers noticed that Stanley was very tired and becoming short tempered because of the intensive work. They told him he had to have a break and took him to Jurong Bird Park where with them, he was able to unwind. "We were almost like boys left off the lead," Stanley recalled. The next day he felt refreshed and was able to return to his work with vigour.

With the restoration complete, the murals could once again be seen as they were originally intended – with the figures moving along the chapel walls toward the altar. As a finishing touch, the ladies of the British Association raised funds and provided a blue altar screen. Placed in the position of the original screen, it masked the windows and door at the end of the room and brought the entire composition into a coherent whole.

* * *

In 1985, Stanley's original drawing of 'St Luke in Prison' was discovered in the memorabilia of Wally Hammond who had been a prisoner with Stanley. From this draft, Stanley was able, in 1988, to paint a small picture of the mural. He was, by then, not fit enough to restore the mural itself. This painting is now displayed below the remaining part of the original mural of St Luke in his chapel.

Despite all that Stanley had done to forget the war, once he was named the painter of the murals, he was constantly reminded of it. He received letters about the murals from all over the world and some people would say how the murals had changed their lives.

Stanley found this to be somewhat frightening for, to the contrary, he said the murals had made him humble. He once said, "I never know when they would constantly arise again. I now know there was no escape from the murals."

Stanley never saw the murals again after 1988. His work completed, he died in Bridport, England, on 20 February, 1992, at the age of 75.

Notes

1. Shaun Hope, an old student at Sir William Collins remembers: "I believe I was taught by Stanley at Sir William Collins Secondary School 1960–65 where he was Head of Art. We knew he had been a prisoner of the Japanese and he had a funny walk which we attributed to his brutal treatment. He was gifted at art and a natural teacher who just naturally commanded respect."

2. Stanley developed a close relationship with the boys, who, as they slowly learned more and more about the murals and the war, were disturbed by what they heard. Stanley was then, at his own request, housed in camp with the boys. One night, he had a nightmare. "I was lying there and I suddenly realised where I was… [you] wake up and you could hear the screaming from the top of the ward. That was the block next door, the whole top floor, the ward was taken with these prisoners. And

in particular, one naval petty officer had this worm infection of the brain, he'll be screaming all night, 'I know you want me to die but I'm not going to…' It'll go on all night like this – screaming…. I woke up… and I could hear the screaming. Walked out on the balcony and [the boys] were watching me. It's quite amazing, some of them, I remember, so young and yet so sensitive." Stanley was invited to attend the passing-out parade of these young schoolboy soldiers. At the reception following the ceremony, they presented him with a plague expressing the high esteem they held him in. An autograph he wrote for one of them read, "I came to Singapore in search of gold and found it." He was touched by the deep warmth and feeling he had encountered.

TS

e Lord, in all things.

...derful that these paintings have been
...d since I was in charge in Sept 1945.
...u feel the peace of this place.
...ing the story + the paintings. To the Lord be praised
...DSSIVE MURAL. PART OF YOUR PAST. KEEP IT AS PART
OF YOUR FUTURE.

...no problem that cannot be solved without war,
...aid indeed.
...nat I had expected....., but impressive! 👍

...S MIST AS I LOOK AT THE MURALS FOR THE TAKE ME BACK TO
...MBER THE MEN WHO SAT, SANG A PRAYER HERE IN THOSE TERRIBLE

...EACE TO ALL !!!
...very historic and educa...
...Still its peacefull its ...
...Very moving.

...Mine eyes have seen the glory!

...Lest We Forget.

A moving memorial of man's cou...

EX AIRMAN IN BLOCK 151 (TOP FLOOR) 1964-67 WHILST WITH ...

"Peace to all"
ARE INSPIRING - NO MORE WARS!

PEACE NO WAR

"Sin but the meek-eyed peace..." (Milton)
We will Remember Them.

Revisited with vivid ...

Epilogue

SINCE THE WAR, CHANGI has grown from a war-damaged army camp with a little village, to an RAF station, and on to a major force in civil aviation with a modern residential area.

With the withdrawal of British troops from Singapore in 1971, the Changi Cantonment was handed over to the Singapore Armed Forces and the fledgling Singapore Air Force. Most of the original Gordon Highlanders' accommodation at Selarang Barracks was demolished and a modern military facility was built in their place for the Singapore Army.

In 1975, Changi started to be developed as Singapore's new civilian airport. The single runway, still on the same line as the original Japanese airstrip, was soon stretched to full capacity. It was not long before the airport required expansion, and land was reclaimed from the sea to meet the need. A second terminal with a second runway and cargo buildings was built over what used to be Beting Kusah Battery. The existing runway was lengthened yet again, obliterating the last visible remains of the Johore Battery, and now stretches well south of Changi Prison.

Building work at Changi seems never to have stopped. A third terminal is under construction. Through land reclamation, the Changi peninsula was extended further out to sea to the east, and in the late

The visitor's book at Changi Museum.

1990s, work began on a large naval base at the south eastern tip of the newly reclaimed land.

South of the airport, Changi Prison is waiting to be demolished. Changi Museum, a small museum containing sobering reminders of the dark days of the war, has been opened. The central courtyard of this museum has a replica of one of the many open-air POW chapels and is used for services. The cross on the altar was made by a POW, Staff Sergeant Harry Stogden, from a 4.5-inch howitzer shell case. In a hall directly behind it are superb full-size replicas of Stanley Warren's five murals.

Near Selarang alongside Abingdon and Cosford Roads is the last reminder of Fortress Changi. In February 2002, the Singapore Tourism Board mounted a replica 15-inch gun as a reminder of Changi's history. Ironically, the orginal gun standing on that site was the only Changi gun that could not turn to fire at the invading Japanese. Below the replica, the magazine and underground rooms built to service the original gun still exist.

Roberts and Kitchener Barracks still stand today, but not for much longer. The old camp area is to be redeveloped as holiday chalets and a new military complex. Block 151, however, will be preserved, and the National Heritage Board of Singapore has taken over the care of the Changi Murals.

Wooden cross and lamp from St Luke's Chapel.

Visitors to the murals today find a well-restored chapel. It is still a peaceful little room with a patina of history. The visitors' book contains names from the world over, including those of many prisoners of the war years. There are many entries by young Singaporeans.

Future generations need the Changi Murals to remind them not just of the futility of war, but man's indomitable spirit in the face of adversity and the

hope of reconciliation. For that was the message Stanley Warren intended when he painstakingly painted them. The murals are his legacy to humanity.

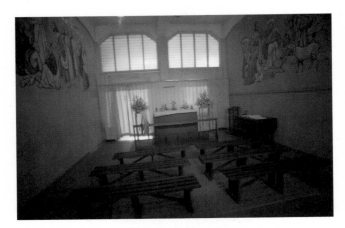

St Luke's Chapel

A Note on POW Chapels

Servicemen are not renowned for religious fervour, but in times of war, like the civilian population, many turn to their particular religion for solace. In Singapore and Malaya, following the Japanese victory, this was manifest in the many small chapels which sprang up in POW camps.

There were at least two chapels in Changi Camp and another two at Changi Prison. St Luke's Chapel in Roberts Barracks was just one of many places of worship constructed. It has survived because it was in a barrack block.

Other chapels no longer exist. An exception to this is one of the chapels which was constructed at Changi Prison. This was dismantled and taken to Australia in 1947. It was reconstructed, partly with new materials, in 1987.

That chapel can now be seen at the Royal Military College, Duntroon, Canberra, where it was officially opened in 1988.

Most of the POW chapels were constructed from wood and attap, and furnishings were constructed from what materials prisoners could get hold of. Items such as crosses and candlesticks were crafted from metals such as brass from shell casings. A splendid cross, constructed from a shell case, can be seen at the replica POW chapel at Changi Prison Museum and a wooden cross and lamp is in St Luke's Chapel.

Appendix 1

The St David's Church Murals

While these murals were first drawn by Stanley Warren at an unamed Bukit Batok camp in 1942, they tend to go by the name of their later location – St David's Church. It is not known how and why the move took place, but they would definitely have been portable, having been painted on asbestos panels. Their re-appearance at St David's is evident both in Haxworth's painting (p. 43) and the National Archives' given description of the murals (p. 43; photos: p. 44–45). St David's Church was located at Sime Road Camp and functioned as a POW internment camp from around 1944. Based on the existing evidence, the murals seem to be better known by their association with St David's Church rather than their original location at Bukit Batok.

Appendix 2

The Nativity mural: the 1963 recreation and the 1982 restoration

The recent discovery of two photos taken in 1967 and 1970 of the Nativity mural by soldiers in Changi sheds some light on different versions of the Nativity mural. Before his restoration of it in 1982, Stanley had actually recreated the mural on wallboard in 1963. At that time, it was still assumed that the original had been destroyed. A new mural was thus painted from

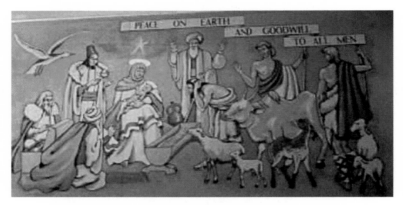

Fig. 1. Photo of the Nativity mural taken in 1967 by George Miller.

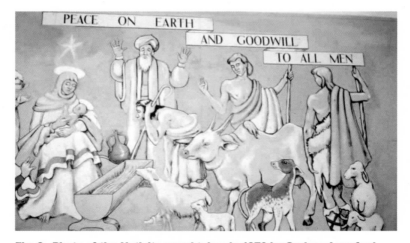

Fig. 2. Photo of the Nativity mural taken in 1970 by Graham Langford.

scratch and placed over the position of the original mural. Stanley only had his memory and an old draft on hand to recreate the mural.

The photos by Graham Langford and George Miller, both British army personnel stationed at Changi after the war, show two obvious differences from the 1982 restoration which still resides in St Luke's Chapel. First, the wording in both Figs. 1 & 2 read "Peace on earth and goodwill to all men" which differs from 1982's "Peace on earth to men of goodwill." Second, in Fig. 1 an albatross replaces the donkey of the 1982 restoration. This left section is not shown in Fig. 2. but the rest of the similarities between the two photos make it likely that the two photos were taken of the same mural.

The presence of the albatross makes it highly likely that these photos were taken of Stanley's 1963 recreation. In a letter to Sqn Ldr J.M. Carder, he confirms that, for this particular mural, he had deliberately replaced the donkey with an albatross to represent the Changi Air Squadron – a change he viewed as permissible as this mural was a reconstruction and not an original. It is not clear if the change in wording was also deliberate or whether it was based on a failed recollection or attempt to decipher what would have been a much-altered preliminary draft.

The 1963 wallboard mural was taken along with the British military when they left, as it was the only portable one. When Stanley returned in 1982 to complete restoration work, the original wall was prepped for the painting of a new Nativity mural. And underneath several layers of paint, the original Nativity mural was discovered.

The restored mural presently at St Luke's Chapel was based on the new discovery: "[O]n the 17th of July … they uncovered the original linework of the whole of the top half of the Nativity. And of course, the wording came through quite clearly. So in deference to history of what was actually there, I put back the original wording despite the fact that I had some theoretical objections to it." (Stanley Warren, Oral History Interview, 1982)

Glossary

FEAF – Far East Air Force
GOC – General Officer Commanding
GSO – General Service Officer
HE – high explosive
HMS – His Majesty's Ship
HQ – headquarters
OP – Observation Post
POW – prisoner of war
RAAF – Royal Australian Air Force
RAF – Royal Air Force
RAMC – Royal Army Medical Corps
RE – Royal Engineers
SAC – Senior Aircraftman
SAF – Singapore Armed Forces

Sources

Note: Stanley Warren's quotes and recollections were mostly sourced from oral history interviews conducted during his 1982 visit to Singapore.

Individuals & Organizations
Changi Prison Museum
Knowledge Net Singapore & Lee Geok Boi
Ministry of Defence and Military Heritage Board, Singapore
National Archives of Singapore
Oral History Department, Singapore
Sentosa Development Corporation
Correspondence with contributors, including ex-servicemen of RAF
 and an old student of Sir William Collins College.

Bibliography
Blackburn, Kevin. "The historic war site of the Changi Murals: a place for pilgrimages and tourism," Journal of the Australian War Memorial, No 34 – June 2001. (http://www.awm.gov.au/journal/

j34/blackburn.htm)

Bryan, J.N. Lewis. *The Churches of the Captivity in Malaya*, Society for Promoting Christian Knowledge, London, 1946.

Elphick, Peter. *Singapore the Pregnable Fortress,* Coronet Books (Hodder & Stoughton), London, 1995.

Kinvig, Clifford. *Scapegoat,* Brassey's, London, 1996.

Percival, A.E. *The War in Malaya,* Eyre & Spottiswood, London, 1949.

Probert, H.A. *The History of Changi,* Prison Industries Changi Prison, Singapore, 1965. Reproduced by SCORE, 1988.

Mirror Group Newspapers

Oral History Department, Singapore. "Oral History Interview. Warren, Stanley. Unedited transcript." Interview dated 7 August 1982.

Warren, Stanley. Letter to J.M. Carder, 12 January 1968. NA 1189, National Archives of Singapore.

Yap Siang Yong, Romen Bose and Angeline Pang. *Fortress Singapore: the Battlefield Guide,* Times Books International, Singapore, 1992.

Pictures

Alexander Turnbull Library's War History Collection 51–54.

Australian War Memorial 20, 22, 26, 46, 76 (bottom), 78, 80.

Heritage Conservation Centre, National Heritage Board 59–62, 63 (top).

Goh Eck Kheng 8, 82, 98, 102.

Imperial War Museum 2, 11, 19, 24, 34.

William R.M. Haxworth (NAS collection) 43, 76 (top).

Graham Langford 105 (bottom).

George Miller 105 (top).

National Archives of Singapore (NAS) 15, 34, 36, 38–39, 73.

RAF Changi Association (*Straits Times* collection) Front cover (bottom), 90.

Sentosa Development Corporation 40, 42, 85, 100.

Singapore History Museum, National Heritage Board 70, 74, 75.

Peter Sanders 93

Peter W. Stubbs 16–18.

Stanley Warren Front cover (top), 28, 47–48, 63 (bottom), 65, 69, back cover; (NAS collection) 31–33, 41, 44–45.

Acknowledgements

RAF Changi Association, Sentosa Development Corporation, Singapore History Museum, Bill Haxworth, George Miller, and Graham Langford for granting complimentary use of their photos.

The author would like to thank Goh Eck Kheng and his staff at Knowledge Net for persuading him to write this book.

About the Author

PETER W. STUBBS was born in 1944 of British parents in Nagpur,
India. He served with Air Despatch Units of the British Army and
met his Singaporean wife Kim whilst serving in Singapore from 1965
to 1968. They live in Darlington in the north-east of England where
he works as a Technology Officer for the Royal National Institute of
the Blind.

"I have known about the Changi Murals since about 1964, but never
really took a great deal of interest in them until I visited them whilst
on holiday in Singapore in 1993. Since then, they have fascinated me
and I have tried to learn as much as possible about them."

Copyright © 2003 Peter W. Stubbs

All rights reserved. No part of this publication may be reproduced or
transmitted in any form or by any means, electronic or mechanical,
including photocopy, recording or any information storage and retrieval
system, without prior permission in writing from the publisher.

While every effort has been made to seek permission for pictures naming
Stanley Warren as source, the publishers were unsuccessful as there was
no known contact for his estate. The publishers extend their apologies,
and wish to contact the relevant estate or parties.

Published by Landmark Books Pte Ltd
5001 Beach Road #02-73/74
Singapore 199588

Landmark Books is an imprint of Landmark Books Pte Ltd

Printed by Craft Print.

National Library Board (Singapore) Cataloguing in Publication Data

Stubbs, Peter W.,- 1944-
 The Changi murals :- the story of Stanley Warren's war /- Peter W. Stubbs. –Singapore:
- Landmark Books,- c2003.
 p. cm.
 ISBN : 981-3065-84-2

1. Warren, Stanley,- 1917-1992. 2. Changi POW Camp (Changi, Singapore) 3. World
War,1939-1945 – Prisoners and prisons, Japanese. 4. Prisoners of war – Great Britain- –
Biography. 5. Prisoners of war – Singapore – Changi- – Biography. 6. Mural painting and
decoration – Singapore – Changi. I. Title.

 D805.S55
 940.547252092 -- dc21 SLS2003032562